Icons

of Piety

Images

of Whimsy

**THE UNIVERSITY COLLEGE OF
RIPON AND YORK ST. JOHN**

The exhibition
*Icons of Piety, Images of Whimsy:*
*Asian Terra-cottas*
*from the Walter-Grounds Collection*
is circulated by the
American Federation of Arts.

Asian
Terra-cottas
from the
Walter-Grounds
Collection

# Icons
# of Piety
# Images
# of Whimsy

Pratapaditya Pal

Los Angeles
County Museum
of Art

Published by
Los Angeles County Museum of Art
5905 Wilshire Boulevard
Los Angeles, California 90036

Edited by Kathleen Preciado
Designed by Renée Cossutta and Judith Lausten
Photography by Steve Oliver
Typeset in Garamond typefaces
by Continental Typographics, Inc.,
Chatsworth, California
Printed in an edition of 2,750 softcover
by Offset-Printing Van den Bossche,
Mechelen, Belgium

Dimensions are in inches (in) and centimeters
(cm), height preceding length. For most
sculptures, height is the only dimension
provided. Diacritical marks have been retained
throughout the text, except for words and
proper names included in *Webster's New
International Dictionary of the English Language,
Unabridged*, second edition. *Webster's New
Geographical Dictionary*, revised edition, has
been consulted for the spelling of modern
place names.

Cover: *Tile with Male Figures* (detail),
Sri Lanka, Kandy District, late eighteenth
century, no. 83a. Frontispiece: *The Divine Hero
Rama* (detail), India, Haryana, Nacharkherha
(?), fifth century, no. 20. Page 8: *Three Monkey
Musicians*, India, Uttar Pradesh, second
century, no. 56.

Library of Congress Cataloging
in Publication Data

Pratapaditya, Pal.
   Icons of piety, images of whimsy.

   Catalog of an exhibition held by the Los Angeles
County Museum of Art and circulated by the
American Federation of Arts.
   Bibliography: p.
   1. Terra-cotta figurines—South Asia—
Exhibitions. 2. Grounds, Marilyn Walter—Art
collections—Exhibitions. 3. Walter, Paul F.—
Art collections—Exhibitions. 4. Terra-cotta
figurines—Private collections—United States—
Exhibitions. I. Los Angeles County Museum of
Art. II. American Federation of Arts. III. Title.

NK4150.6.P73 1987    732'.4'074013
86-27738
ISBN 0-87587-135-6

# Contents

# Foreword

Many exhibitions of Indian sculpture highlight monumental works of stone or metal and often overlook smaller objects used for private delectation or devotion. Such exhibitions, furthermore, may require of the viewer some esoteric knowledge of Indian myth and religion. The terra-cotta objects in the exhibition *Icons of Piety, Images of Whimsy: Asian Terra-cottas from the Walter-Grounds Collection* by contrast are readily accessible. Although some may represent foreign concepts or describe unfamiliar narrative themes, we are not deterred from fully enjoying their elegant simplicity or charming directness.

Terra-cotta objects are by nature familiar. Since for many of us our first artistic endeavors are made of clay, we do not find it intimidating, unknowable. What is more, terra-cotta objects are usually fashioned on an intimate scale. Paradoxically this accessibility may have hindered our recognition of the artistic achievements of those who have worked in the medium. The sculptures presented in this exhibition have been selected to reflect a rich diversity of style and artistic intent. These objects—pious as well as whimsical—continue to enlighten and entertain viewers as they have for centuries.

Terra-cotta sculptures have only recently received critical attention, and scholarly research regarding many aspects of the subject is scant. Pratapaditya Pal, senior curator of Indian and Southeast Asian art, has organized the exhibition and written the accompanying catalogue so that both the scholar and general museum visitor will receive an informative introduction to the subject. In his essay Dr. Pal interprets various classics of Indian literature and offers his own speculations on the purposes for which many of these objects were intended. Individual objects are discussed more fully in the illustrated entries.

The Los Angeles County Museum of Art is pleased to present this outstanding group of terra-cottas, which have been selected from the private collection of Paul F. Walter and his sister Marilyn Walter Grounds. Mr. Walter's willingness to allow these objects to be exhibited for an extended period has enabled the Los Angeles County Museum of Art to join with the American Federation of Arts, which will be organizing a national tour of this exhibition after its Los Angeles opening presentation.

Earl A. Powell III
*Director*
*Los Angeles County Museum of Art*

Wilder Green
*Director*
*American Federation of Arts*

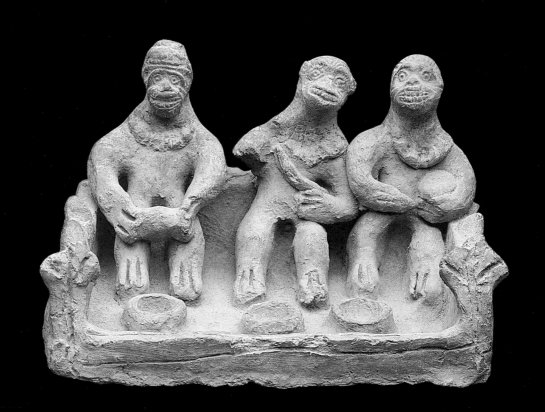

# Preface and Acknowledgments

This exhibition and catalogue include a selection of terra-cotta objects from the collections of Paul F. Walter and his sister Marilyn Walter Grounds. The combined collections of South and Southeast Asian terra-cottas are the most comprehensive either in public institutions or in private hands. While most major museum collections of Asian art contain some examples of terra-cotta art from South and Southeast Asia and a few have a more extensive range of Indian terra-cottas, the Walter-Grounds collection remains unique for its wide geographical distribution and diversity of forms. It is especially gratifying that this group of objects has been promised to the Los Angeles County Museum of Art, where the Indian collections have been enormously augmented by generous donations from several members of the Walter family in the past.

The terra-cottas are from Pakistan, India, Nepal, Tibet, Sri Lanka, Burma, Thailand, and Indonesia. Most objects are sculptures made for sacred and secular purposes. The collection also includes forms of architectural material, such as painted and glazed tiles. The exhibition does not include pottery, although one or two Javanese objects may have adorned pots.

Each object in the exhibition was rigorously examined and tested in the museum's laboratory. These tests were conducted by Peter Dammers, under the direction of Pieter Meyers, head of the Conservation Center. It is hoped that their final study will one day be available for scholars.

Many people contribute to the success of an exhibition and its catalogue. In fact, every department of the museum is involved in the preparations of an exhibition and to name all who have contributed to presenting *Icons of Piety, Images of Whimsy* would require a listing of the entire staff. I am indebted to all but would like to mention Director Earl A. Powell III; Myrna Smoot, former assistant director for Museum Programs; and Managing Editor Mitch Tuchman for their ungrudging support.

Special mention should also be made of the staff of the library and the following individuals for valuable assistance: Janice Leoshko, Stephen Markel, and Ethel Hyer of the Department of Indian and Southeast Asian Art; Tom Jacobson of the Department of Publications; and Robert L. Brown of the University of California, Los Angeles.

Pratapaditya Pal
*Senior Curator of Indian and Southeast Asian Art*

# Introduction

*For 'tis not verse, and 'tis not prose*
*But earthenware alone*
*It is that ultimately shows*
*What men have thought and done.*[1]

Of the various materials used by men and women since early times, whether for shaping a dwelling or fashioning sacred images or articles for daily use, clay is certainly the most easily accessible and versatile and has remained popular in many parts of the world, including South and Southeast Asia. Until the invention of plastic, no other material has served rich and poor alike as well and with such diverse utilitarian and aesthetic purposes as clay, whether sun-dried or hardened by fire (terra-cotta). In many ways clay is also the most elemental of materials used for artistic purposes. Nothing intrudes between the maker and the material while the clay is worked. A clay object, whether unfired or fired, is a direct expression of the human imagination, or "formative nature," to use an expression by the German poet Goethe. Although the artist may take advantage of the wheel or the mold to create a pot or figure, by and large the maker's bare hands are the tools with which the material is manipulated into the desired shape and form.[2]

With few exceptions, the objects assembled in the Walter-Grounds collection are made of unglazed terra-cotta. They were either modeled by hand or made from molds or are the result of combining both methods. The objects range in date from the third century B.C. to the eighteenth century and have a wide geographical distribution from the Indian subcontinent (including Pakistan and Nepal) as well as Tibet, Sri Lanka, Burma, Thailand, and Indonesia. The few glazed objects are from Burma and Thailand. Although no object was discovered in a specific archaeological context, excavations in India have yielded many terra-cottas, so that dating the material is not difficult. Less easy to attribute are the objects from Sri Lanka and Java for which available research is scarce. The Sri Lankan literature on the subject consists of a few brochures published by the Department of Archaeology, but the material analyzed was not found in any scientific excavation. Similarly the few recent studies on Javanese terra-cottas are based primarily on surface finds, and this lack of information is reflected in the title of the only book on the subject published to date, *Javanese Terracottas: Terra Incognita.*

The terra-cottas discussed here were made for many different purposes. Their sizes also vary considerably depending on their functions, although most terra-cotta objects are small and easily carried. Unlike the surviving stone and bronze sculptures from South and Southeast Asia, which generally depict religious subjects and were intended primarily for temples and monasteries, terra-cotta

objects were made for secular as well as religious purposes. Indeed, terra-cotta objects comprise the richest single source for not only appreciating aesthetic and spiritual aspirations but also for learning about everyday life, especially for cultures that have left us little written material or that no longer flourish.

Far more than stone, bronze, or the less-durable medium of painting, terra-cotta can be used to create profane as well as sacred images. Artistic license finds expression not only in secular artifacts but also in religious and votive objects. For example, beginning with at least the fourth millennium B.C. on the Indian subcontinent, countless figures of both sexes were made that are generally identified as yakshas, apsarases, or mother goddesses. Not only are we uncertain of their exact identity or religious function, but their forms differ significantly from one region to another. It would seem that the artist creating terra-cotta icons of piety was guided only by tradition (except when shaping images for Brahmanical and Buddhist use) rather than by iconographic manuals or rigidly enforced injunctions as were sculptors who produced stone or metal objects for temples and monasteries.

Terra-cottas are also an important source of information for the anthropologist, for in many ways they straddle both the Great and Little traditions. The theory that a civilization is a "compound structure of Little and Great Traditions" was first put forward by the anthropologist Robert Redfield in the early 1950s.[3] Basically the Great Tradition "is a *learned* and a *literate* tradition, preserving and developing the dominant systems of thought and value of a civilization" as opposed to the nonliterate, grass-roots cultural heritage of the Little Tradition.[4]

To put it another way, beginning with the arrival of the Sanskrit-speaking Aryans in the second millennium B.C., progressive "Sanskritization," to use an expression popularized by another eminent anthropologist, M. N. Srinvasan, has dominated the development of Indian civilization. To a great extent this is true of Nepal and Sri Lanka as well. Although the societies and cultures of Tibet, Burma, Thailand, and Indonesia have been significantly influenced by Indian civilization, they did not succumb to the process of Sanskritization as had the non-Aryan peoples and cultures of the Indian subcontinent. Nevertheless, the concept of the two traditions is also generally valid for Southeast Asian cultures and civilizations. While one can learn about the Great Tradition of a civilization by simply relying on literary sources, cultural anthropologists consider the art of terra-cotta an essential tool for the understanding of the Little Tradition. Not only does clay, along with folk painting, remain the principal medium for expressing ideas of the Little Tradition, but it often demonstrates the interrelation of the two traditions. Furthermore, the continuity of a given tradition survives much longer in terra-cotta than it does in other artistic media, as for example in the timeless image of the mother goddess.

The earliest terra-cotta sculpture in the collection dates to the third century B.C., but the history of the medium on the Indian subcontinent begins in the fifth millennium if not earlier. Various prehistoric sites in the northwest of the subcontinent have yielded an abundance of terra-cotta representations of animal and human figures, mostly female. South Indian cultures, whether prehistoric or historic, seem to have been less interested in the art of terra-cotta than were cultures of the north. The only south Indian terra-cottas included in the collection are from second-century Maharashtra (no. 6a–b).[5] Clay and terra-cotta sculptures, however, form an essential part of the religious life of south Indian villages, and although the examples seen today are not very old, their tradition dates to antiquity.

Until the third century B.C. the principal sculptural medium on the subcontinent was terra-cotta. Especially favored in urban settlements, terra-cotta was used to produce a wide variety of animal and human figures as toys and votive offerings and for many other purposes. The human figure may have also been used as a model for a ritual fertility image, mother goddess, or talisman. Even today terra-cotta figures serve these basic purposes in village India. Some sculptures, both of animals and humans, may have served a purely decorative function, perhaps adorning niches in the home. One curious aspect of prehistoric Indian terra-cotta sculptures is the fact that animals are always more naturalistically rendered than are humans. As Raymond and Bridget Allchin have remarked: "With these Harappan terra-cottas we notice for the first time a general tendency which is repeated many times in later Indian art: the plastic qualities of the animals are as a rule more noteworthy than those of the human beings, and show considerable skill on the part of the artist in representing natural observation."[6]

The religious practices of the Aryans—as contained in their texts known as the *Vedas, Aranyakas,* and *Brahmanas*—consisted primarily of sacrifices and fire rituals. Their religious texts reveal little of the type of devotional worship requiring the use of terra-cotta figures. One might say that since the Vedic literature generally preserves the religious ideas of the Great Tradition, the devotional practices of the Little Tradition were not recorded. Nevertheless, some passages are relevant to the subject.

Even if divine images were not part of the Vedic Aryan's religious observances as revealed in Vedic texts, it would be wrong to suppose that none was used at the grass-roots level for various propitiating, prophylactic, and magical purposes. The cults of such celestial spirits as the apsarases, gandharvas, yakshas, and various other village, folk, and nature deities may well have involved votive offerings of clay and terra-cotta. Certain hymns and rituals in the *Atharvaveda* certainly seem to imply the use of images. One invocation to a popular triad of Vedic goddesses reads: "Unto our sacrifice let Bhāratī come quickly, let Idā taking note here in human fashion; let the three goddesses, well-working, sit upon this pleasant *barhis* [sacrificial grass]—[also] Sarasvatī."[7] The passage may indicate that for certain rites terra-cotta images of the goddess ("in human fashion") were placed on sacrificial grass. Interestingly a Sri Lankan terra-cotta in the collection represents a triad of three goddesses (no. 11), and similar images may well have been used in Vedic times as well. Elsewhere in the same text information is provided about statuettes, or dolls, made to be used in witchcraft. Known as *kṛityās,* these female figures could

*be fashioned by men or women or by a Brāhmaṇa, Kṣatriya (Rājan) or Śūdra. Like a bride decorated for the marriage procession, she is to be skilfully decorated. She has a head, nose, and ears, and has variety of forms and is adorned with a crest. She has joints. The sorcerers bury her in the sacred grass* (barhis), *field, cremation ground* (śmaśāna) *or in the household fire.*[8]

While the text does not identify the material from which these objects were made, it is not improbable that it was clay.

In an article published in 1974 Wilhelm Rau discussed some fascinating material regarding the manufacture of earthen vessels used in Vedic rituals.[9] One of these, known as the *ukhā,* was employed as a portable vessel for containing sacrificial fire, another, the *mahāvīra,* was used as a pot for boiling milk. The Vedic texts not only provide detailed accounts of the process of making these

containers—from selecting the clay and additives to the method of kneading, modeling by hand, and firing—but the associated mantras make it clear that women were generally responsible for kneading and shaping the vessels and men in mixing the clay and baking, which is still the practice among potters in many parts of India today. Additives used in preparing the clay for the *ukhā* included ground lime pebbles, goat's hair, and unspecified metallic compounds. Among additives for the *mahāvīra* were pounded potsherds from deserted settlements and hair from black antelope skin as well as clay from an anthill or a spot torn up by a boar. As Rau noted, the materials and techniques described for ritual pottery may not have differed greatly from terra-cotta objects made for utilitarian or devotional use.

Although several sites in Pakistan belonging to the Gandharan grave culture, dating from about 1700 to 400 B.C., or Kayatha near Ujjain in Madhya Pradesh and Inamgaon near Daimabad in Maharashtra of about the same time have yielded terra-cotta animal and human figures, by and large the period is not well represented by terra-cotta or, for that matter, other art forms except painted pottery.[10] Thereafter, however, especially from the third century B.C., most urban centers along the northern trade route, such as Ahichchhatrā, Kausambi, Mathura, and Rajghat in Uttar Pradesh, the Patna region in Bihar, and various sites in West Bengal, such as Chandraketugarh and Tamluk, to name only a few, became active centers of terra-cotta production, and some remained so at least through the Gupta Period (320–700).[11]

Most terra-cotta objects produced in the urban centers of the Ganges Valley or in Maharashtra and Andhra through the early centuries of the Christian era are relatively small. They were modeled by hand or made with molds, the latter method proving to be more popular from the second century B.C., no doubt to meet a greater demand. Examples from the Kushan period (50–200) demonstrate that larger sculptures, intended probably for more permanent shrines, were also made (nos. 5, 7). As very little is known of the early architecture of India, it is not clear whether brick structures, both sacred and secular, in the early centuries of the Christian era were embellished with terra-cotta plaques as they were during the Gupta period. Indeed, brick temples adorned with terra-cotta sculptures and reliefs appear to have been much in demand during the Gupta period, and several panels in the collection (nos. 20–24) were made for a specific architectural context. In some parts of India, such as Bengal, terra-cotta panels remained the principal mode of decorating temples well into the nineteenth century.

The small group of terra-cottas from Sri Lanka included here are among the most intriguing. As the available literature on the subject is scarce, it is difficult to be certain of either the exact provenance or precise dates of these pieces. Most are ocher-red, often crudely modeled and shaped, and some appear to have been painted black. The figures are often informed with a whimsical naïveté that makes them particularly appealing. Most relate to fertility cults, and the Buddhists in Sri Lanka, unlike the followers of the faith elsewhere, do not seem to have made much use of terra-cotta votive plaques. The two painted tiles in the collection (no. 83a–b) are fine examples of late eighteenth-century painting, although whether they belonged to a Buddhist structure or a secular building is difficult to ascertain.

Technically more sophisticated are the terra-cotta objects from Nepal and Tibet. Although no example in the collection can be dated earlier than the fifteenth century, terra-cotta appears to have been a fairly popular material from early times in these Himalayan countries.[12] Once again very little has been written about the art of terra-cotta in either country. Archaeological and epigraphical

evidence from Nepal confirms the use of terra-cotta for sculpture as early as the fourth or fifth century. Many early Tibetan monasteries contain impressive, brightly painted Buddhist images made of clay or terra-cotta. Moreover, Tibetans used terra-cotta extensively to make small votive plaques (*tsa tsa*), which were often inserted into metal images. A fine eleventh-century example included here (no. 31), probably made in India, was, in fact, removed from a Tibetan bronze image.

Most terra-cotta objects from Burma and Thailand were made for Buddhist shrines. Molded votive tablets (see no. 28) were popular in both countries, and the collection contains several well-preserved examples (nos. 29, 32–33). In keeping with the Theravada Buddhist practice of worshiping only images of Buddha Sakyamuni, in Burma and Thailand, where this tradition is followed, representations on tablets consist generally of Buddha images. Burmese and Thai terra-cotta plaques were probably modeled after similar tablets made in large numbers in the most sacred of all Buddhist sites, Bodhgaya in Bihar, where the Buddha was enlightened. Southeast Asian pilgrims must have carried back these easily portable tablets as holy souvenirs. In Thailand and Burma such tablets were often inserted into stupas and other religious edifices, no doubt to enhance their spiritual power.

Terra-cotta was also used extensively in Thailand to create images for brick temples. The two examples in the collection, one representing the Buddha Sakyamuni (no. 35) and the other an unidentified figure (no. 36), were probably made in the thirteenth century in the ancient kingdom of Haripunchai, which flourished from about the seventh until the end of the thirteenth century.

Also in the collection are several examples of glazed ceramic sculptures and tiles from Burma and Thailand. The two Thai sculptures (nos. 65, 81) are from Sawankhalok, an active center of ceramic production during the fourteenth and fifteenth centuries.[13] While much has been written about Thai ceramics, almost nothing is known about the tradition in Burma. In both countries the manufacturing of glazed ceramics was introduced when the region came into contact with China near the close of the thirteenth century as a result of the vigorous expansionist policy launched by the Yuan emperor Kublai Khan (1215–1294). Almost certainly Chinese potters were present in Sawankhalok during the fourteenth century, and some may have penetrated further west into Burma to begin ceramic centers there. While Thai artists produced a wide variety of glazed ceramics for export throughout Asia, their Burmese counterparts seem to have confined themselves to making glazed figurative tiles largely for local consumption. The two pairs of Burmese tiles included here (nos. 67, 84) were made for Buddhist shrines and display the technical dexterity and inventiveness of the Burmese, for nothing quite like them has been found elsewhere.

The Chinese presence in Southeast Asia during the last decade of the thirteenth century seems also to have inspired a flourishing terra-cotta tradition in the Indonesian island of Java.[14] The collection includes a large and impressive group of Javanese terra-cotta objects of remarkable variety and exceptional quality. As Sawankhalok was the most important ceramic center in Thailand during the fourteenth century, Trawulan, ancient capital of the Majapahit Kingdom in East Java, produced the greatest number of terra-cottas that have so far been recovered in Java. The kingdom was founded in 1293 by Kritarajasa Jayawardhana (r. 1293–1309) with the help of the Chinese expeditionary force sent by Kublai Khan the year

before. Although the vast quantities of terra-cotta objects found in and near Trawulan have not been thoroughly analyzed, it is known that they were recovered from layers also containing glazed pottery from China and Thailand dating from the thirteenth to the fifteenth century.

A large community of Chinese settlers in the Majapahit capital is also documented in the 1433 itinerary of the Chinese traveler Ma Huan. Furthermore, numerous terra-cotta sculptures have been found that depict ethnic types, which may represent Chinese peoples or deities (see no. 38). Glazed ceramics do not appear to have been produced in Trawulan as they were in contemporary Sawankhalok.[15] Indeed, the importance of terra-cotta as a medium for Majapahit sculpture and architecture is somewhat mysterious, considering that in the sixth to eleventh centuries stone was by far the most popular material for religious art and architecture. It is possible that terra-cotta objects adorned secular buildings during the period and have either not survived or remain unexcavated. Nevertheless, considering the fairly wide use of terra-cotta in Gupta India, as well as in the Dvāravatī Kingdom (sixth–eleventh centuries) in Thailand, it would not be unusual for architects and sculptors in Central Java to have used this material, although more sparingly. Whether inspired by the Chinese or not, fourteenth-century artists of the Trawulan region obviously delighted in the use of terra-cotta. Both the refinement and rich diversity of the objects indicate that they were intended for a clientele of discriminating taste and aesthetic sensibility.

## Icons of Piety

From the earliest times on the Indian subcontinent icons of piety have consisted largely of female or animal figures. Among the latter, the bull is probably the most popular, but elephants, monkeys, dogs, horses, roosters, birds, and various other animals are also frequently encountered. The bull figures prominently on Harappan seals from the third millennium B.C. as well and has retained its eminence in the Hindu religion as the vehicle of the god Siva. Very likely these terra-cotta animals were placed as sacrificial substitutes offered to the gods at village shrines, especially below sacred trees, as is still done today. Some were possibly used in particular rituals and festivals to enhance fertility or appease malevolent spirits. Many could not afford to sacrifice live animals and resorted to offering clay surrogates, which may also explain why animal figures are generally represented naturalistically, whereas humans are modeled more abstractly.

In some regions, such as the northwestern parts of the country, where the Gandharan grave culture flourished from about 1700 to 400 B.C., terra-cotta figures of both humans, mostly female, and animals have been found in graves. Similar figures have also been discovered from megalithic burial sites in southern India of the first millennium B.C. Thus at least for a time in those societies where internment prevailed, terra-cotta images served some ritual function in funerary rites. During the historical period, however, when cremation rather than burial became the predominant mode of disposing the dead on the Indian subcontinent, the practice was discontinued.

While the lively terra-cotta animals can be admired simply as works of art whether or not we know their contextual function, more difficult to understand are the female figures that are so prominent from the prehistoric period

until the early centuries of the Christian era. The earliest example in the collection (no. 1) belongs to the third century B.C. Scores of such figures modeled by hand except for the heads, which were often made from molds, have been found in Mathura. Except for the arms and legs, the figures are usually well modeled. They have neither feet nor hands and were certainly not meant to stand. They also bear no traces of ritual unguents, which would preclude their use as images in shrines, whether public or private. Even after more than two millennia their details are remarkably well preserved. Moreover some examples have survived almost intact. Apart from the obvious emphasis on the breasts and hips, the most prominent iconographic feature of such figures are their elaborate headdresses, which they share with many of their forebears. Unlike the near-contemporary "baroque" ladies from Pakistan (no. 2), these Mathura females are not nude but richly attired and ornamented.

The so-called baroque lady continues the figural type popular in the northwestern regions at least from the fifth millennium B.C. Another curious survival is a bird-headed female with several infants attached to the body (no. 8). Females with animal heads were especially popular with prehistoric societies and are also encountered as late as the Kushan period in both stone and terra-cotta. Images of females nursing multiple babies are still made in India and are generally identified with Sashthī, a fertility goddess and protector of children.[16]

A third early type of female figure probably meant for devotional use is represented here by a well-preserved, solitary example from Kausambi in Uttar Pradesh (no. 3). Unlike the Mathura figure or baroque ladies, this type has been encountered in several sites as far east as West Bengal. They are most frequently represented in high relief on rather shallow plaques, some with holes at the top, indicating that they may have been hung on walls. Like the Mathura figures, they also are profusely ornamented and wear elaborate headdresses, which must have been especially significant. In this particular example the lady also stands hieratically on a lotus, thereby clearly announcing her divine nature. Scholars have generally sought to identify such early figures as symbols of fertility and abundance or as mother goddesses. Some have been identified with specific Hindu goddesses.[17]

That such figures served a pietistic purpose is not questioned, but attempts to identify them more specifically, while challenging, are perhaps unproductive. The variety of such early figures, produced especially between the third century B.C. and second century A.D. across northern India as well as the Deccan, is enormous. While a few types seem to have been known in more than one center, and a few features, such as the elaborate headdress, are shared in common, most have highly localized forms and belong to a particular period. For instance, while the baroque ladies of Pakistan (no. 2) with their strongly geometric forms and nudity continue an earlier type, they are not encountered elsewhere in the subcontinent. The curious figure of the nursing mother with several children (no. 8), also from Pakistan, is unique to the region and may well be a folk version of the Buddhist goddess Hārītī, whose cult was very popular in that part of the subcontinent during the early centuries of the Christian era. The gray-black figure with luxuriant headgear and stumpy arms and legs (no. 1) is peculiar to Maurya-period Mathura (321–187 B.C.). While she may have survived into the first century B.C., certainly by the Kushan period she had outlived her usefulness. The most prominent female figures of Kushan Mathura are generally much larger and are seated in the so-called European posture with or without attributes (see nos. 5, 7) and occasionally with children.

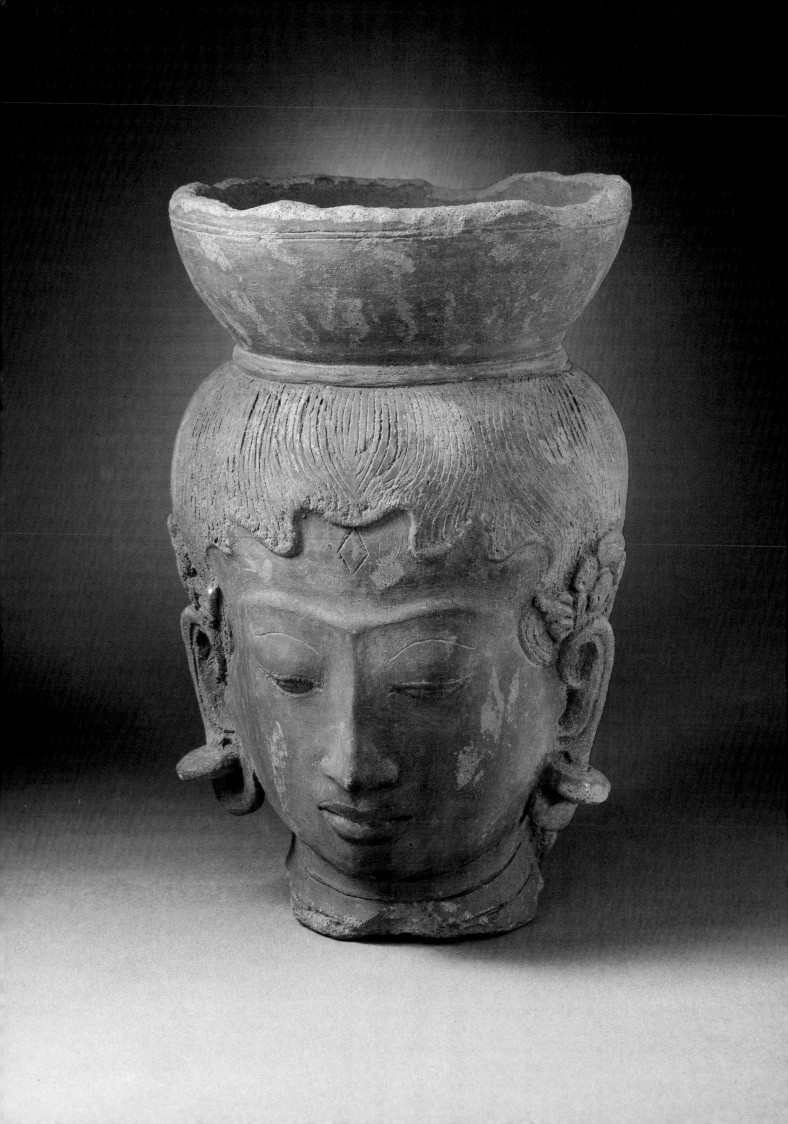

Very likely the figures served different functions in different periods. It has already been pointed out that the *Atharvaveda* describes the practice of making beautifully adorned female figures dressed like brides for use in special rites associated with the *kṛityās*. These images were simply placed on sacrificial grass or under the earth in cremation grounds. The Maurya-period Mathura images (see no. 1) not only suit the description of such figures admirably, but the fact that they are well preserved and cannot stand by themselves may be accounted for if they were simply buried underground in magical rites to enhance the fertility of the land or for other purposes.

Some may have represented apsarases and yakshis who were, and still are, the foci of local cults across northern India, as is known both from the early literature and artistic evidence. Yakshis feature prominently on the stone railings of the second-century B.C. stupa at Bharhut in Madhya Pradesh, where they are identified by inscriptions. Pronounced iconographic and formal differences, however, distinguish these stone sculptures and contemporary terra-cotta figures. For example, the Bharhut yakshis are frequently depicted standing near trees or on crouching mounts, neither of which are commonly seen in terra-cotta figures. Nevertheless not only every village but every town in ancient India had a local yaksha or yakshi who served as its tutelary deity. Some terra-cotta females may well represent such tutelary or guardian deities of settlements; in fact, since several examples of the Kausambi plaque (no. 3) are known, the figure on it may well represent the goddess of that city. Curiously male figures are comparatively rare among early images of piety.

Since these figures belonged largely to the Little Tradition, the brahmans responsible for the religious literature of the Great Tradition were not interested in precisely discussing the function or significance of these objects. Some of these deities were, of course, adopted into the Buddhist, Hindu, and Jain pantheons and appear in new guises during the historical period. The literature of all three religious systems includes general information about numerous local cults devoted to various goddesses. For instance, a very early cult for the protection of children centered around the deity Revatī, who later became the spouse of the Hindu god Balarama. While she is known from various scriptural texts, such as the puranas, her importance for the daily life of the people can best be gauged from medical treatises. One such significant text is the third-century *Kāśyapasaṁhitā*, an entire section of which is devoted to the cult of Revatī. As noted by J. N. Tiwari:

*In this section {the* Revatīkalpāddhyāya*} Revatī appears not as an afflicter of human beings but, on the contrary, as a goddess who, on the instructions of Skanda-Kārttikeya, protects them against afflictions by other evil beings. She is said to be of many forms,* Bahu-rūpā, *but her principal form is Jāta-hāriṇī {fetus stealer ?}, and, in fact, the two names, Revatī and Jāta-hāriṇī, are indiscriminately used throughout this section of the text to denote the same goddess. It is also said that Revatī-Jāta-hāriṇī is of three types, divine, human, and pertaining to the animal world, and pervades the animal world in her various forms. She is* sarva-loka-bhayaṁkarī *{universally dreaded} and revered even by the gods for the growth and long life of progeny.* [18]

Indeed, this is still the primary purpose of the goddess, and in diverse forms and with different names she is propitiated in every village and town in India. While Durga, Ganesa, Siva, Vishnu, and others may dominate the Great Tradition, at the

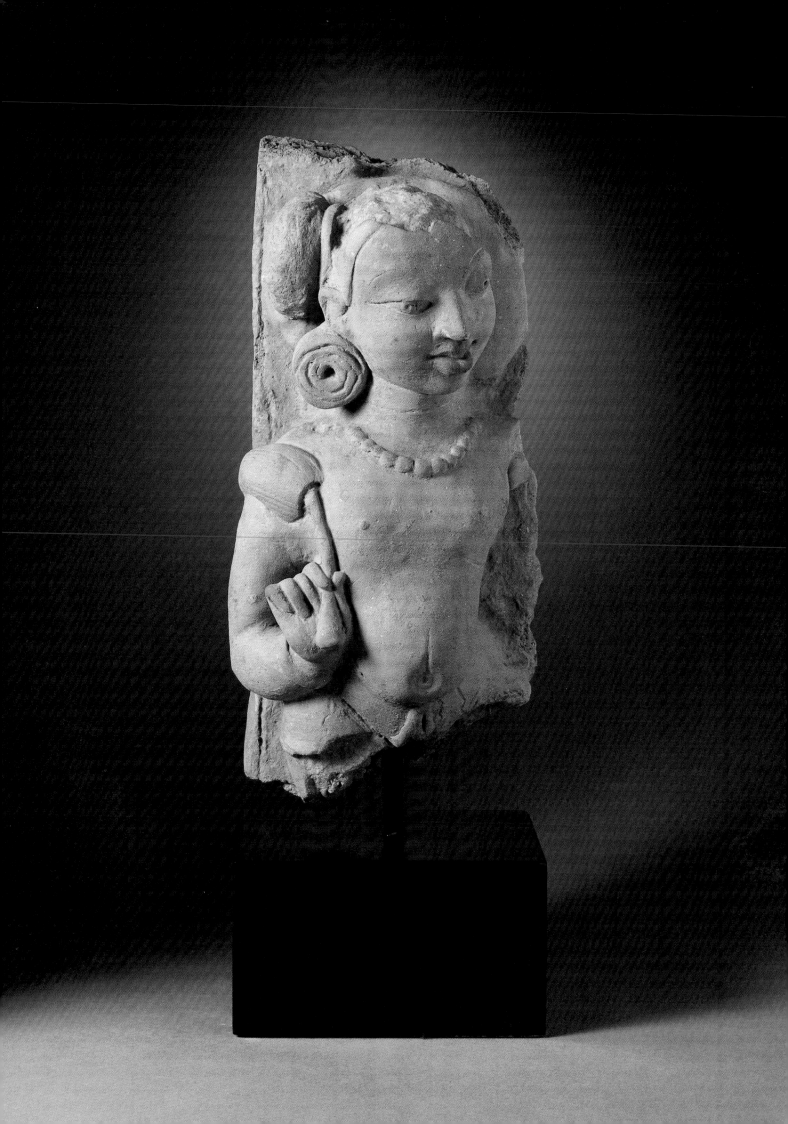

grass-roots level goddesses like Revatī and her successors, whether known as Ambikā, Sashṭhī, or simply Devi, remain a ubiquitous presence in the daily life of the people. The *Kāśyapasaṁhitā* enumerates dozens of Revatī's forms and classifies them "according to various geographical regions and tribes covering practically the whole of India, and also according to various professional groups like blacksmiths, carvers, carpenters, potters, cobblers, garland-makers, tailors, washerwomen, cowherds, etc."[19]

Thus, the fish-bearing goddess may well represent either the tutelary goddess of fishermen or Revatī, goddess of fishmongers. The seated goddesses of Kushan Mathura may well represent Revatī or one of her numerous counterparts, such as Bahuputrikā, Karālā, Putanā, or Sashṭhī. In this context Putanā was a very important goddess in the Mathura region: in the Krishna legends she attempts to poison the infant Krishna but is destroyed by him. Many such figures were probably made for special rituals connected with childbirth and the vulnerable early days of infancy but were discarded thereafter in tanks, ponds, and rivers. The enormous Kushan-period reservoir discovered at Sringaverapur near Allahabad has yielded several terra-cotta images of goddesses like some included in the collection (nos. 5, 7).[20] The practice of immersing clay icons in water after their worship on special occasions is still popular in many parts of India but especially in West Bengal.

That clay was the principal medium for making divine images during the Gupta period is known not only from artistic evidence but also from contemporary literature. In his encyclopedic work, the *Bṛihatsaṁhitā,* the great astrologer Varāhamihira (active sixth century) mentions seven materials used to make icons and lingas, of which clay was the second most popular.[21] The collection includes a small, but well-preserved Śivaliṅga (no. 19) that was very likely used in a domestic shrine. Among other Hindu deities represented are Durga, Ganesa, and Kubera. Small terra-cotta Durga images were especially popular between the first and fifth century, and one wonders whether some were carried by generals onto the battlefield as talismans. Varāhamihira also gives us some information about the potters who produced not only vessels for daily use but also bricks as well as figures. Like most other artists and traders, potters lived in a particular section of a village or town, where they constituted their own guilds.

In addition to images of gods and goddesses, terra-cotta reliefs were in great demand during the Gupta period. The popularity of brick structures in Gupta India can hardly be gauged from surviving examples. If it were possible to compile a complete inventory of the brick temples of the period, one would probably find that Gupta-period architects generally preferred brick to stone. Brick temples were profusely adorned with terra-cotta images of gods and goddesses—some of which were of impressive proportions, such as the well-known pair of river goddesses from Ahichchhatrā (Harle 1974, pl. 139)—and panels depicting narrative and mythological themes. Most surviving panels represent either Saiva or Vaishnava themes, among the latter the epic *Ramayana* being a far more popular source than the *Mahabharata.* Not only does the collection contain the earliest known inscribed terra-cotta representation of Rama (no. 20) but several other fragments may well have depicted other stories from the epic (nos. 21, 23–24).

Unfortunately the exact provenance of such terra-cotta panels, a large number of which have appeared in the art market in the last decade or so, cannot be determined. Some are said to have emerged from an unknown site near Allahabad

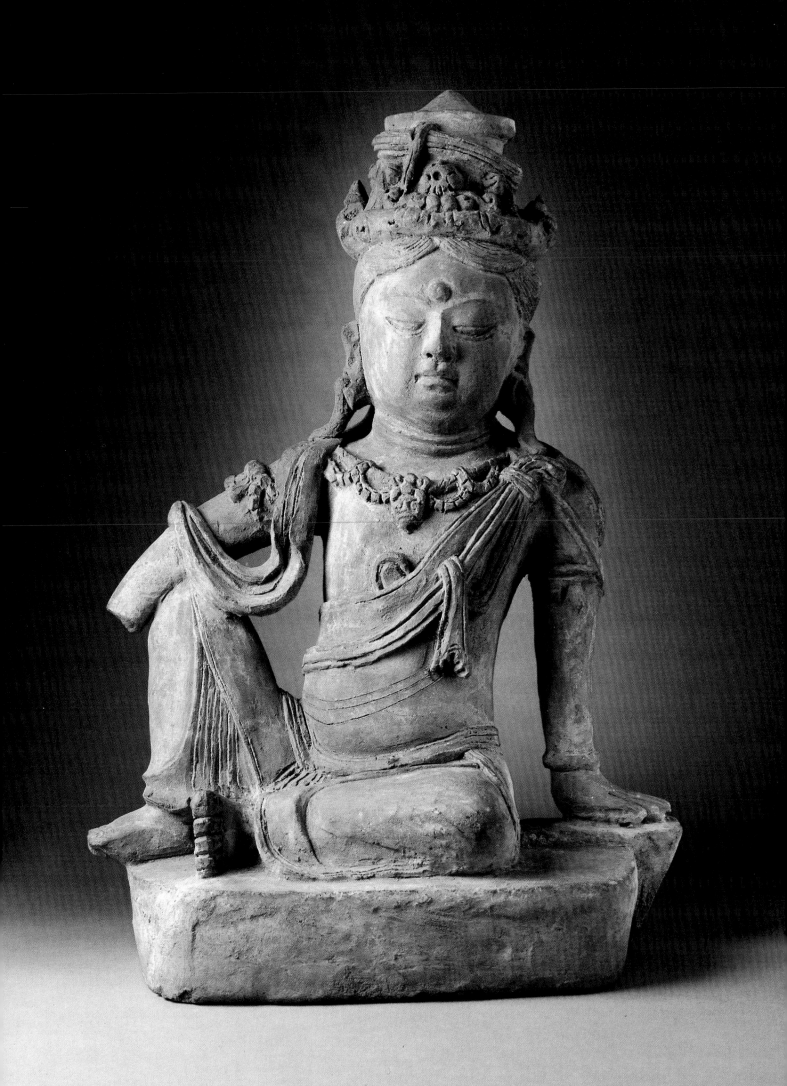

in Uttar Pradesh. Others may be from Madhya Pradesh. Several other inscribed panels recently attributed to Uttar Pradesh may be from Nacharkhera in Haryana.[22] What is interesting is that whether found in Uttar or Madhya Pradesh or in Haryana these panels are rendered in such a uniformly consistent style that one wonders if the master molds were not manufactured in the same workshop. In fact, while the small figures from northern India display a remarkable stylistic variety from one region to another as do stone and metal sculptures, Gupta-period terra-cotta temple reliefs reflect an astonishingly homogeneous style of consistently high quality. There is nothing naïve or crude about either the modeling or technique of these temple terra-cottas and no discrepancy between them and their lithic or metal counterparts, as there is between terra-cotta and stone sculptures from Kushan Mathura, for instance. The unknown master sculptors responsible for these terra-cotta panels have given us perhaps more varied and expressive representations of the mellifluous plasticity, suave elegance, and graceful sensuousness that are the hallmarks of the Gupta aesthetic than have their colleagues working in stone and metal.

The Buddhists too must have made much use of terra-cotta sculptures to adorn their temples and monasteries during the Gupta period and later, especially in Uttar Pradesh and Bihar, but the surviving remains are less impressive than those from Hindu temples. Nevertheless, the Buddhists made extensive use of small terra-cotta votive plaques, or tablets, to propagate their faith in a way that was emulated neither by the Hindus nor Jains. It would appear that every important Buddhist pilgrimage center, but especially Bodhgaya, produced vast quantities of terra-cotta tablets that could be put to various uses and be taken away by pilgrims. Only affluent pilgrims could afford to buy bronzes, whereas terra-cotta tablets were both cheaper and lighter to carry on long and arduous journeys. Indeed, art historians have been curiously reticent in considering the importance of such humble terra-cotta tablets and molds or, for that matter, coins for the diffusion of artistic styles from one region to another. Moreover, although made of clay, the artistic quality of the images on the tablets is in no way inferior. The collection includes several examples from India, Burma, and Thailand that are well-preserved, fascinating documents of cultural history (nos. 28–29, 31–34).

Terra-cotta was a popular medium for religious sculpture in Thailand from early times and was often more sensitively modeled than was stone. The thirteenth-century terra-cotta sculptors of Haripunchai were especially inventive and skillful, creating most distinctive and powerful Buddhist images.

Although only a small group of religious images from Nepal and Tibet are included in the collection, they are fascinating for their unusual subject matter and refined execution. The remarkably composed and modeled relief representing an elegant lady visiting a cremation ground (no. 41), probably portraying one of the Buddhist *mahāsiddhas* (perfected beings), is surely an aesthetic tour de force. Here is a subject that is clearly bizarre and gruesome, and yet the realistic details are handled tastefully and with restraint. One can well say that this finely modeled composition describes the horrific sentiment (*vībhatsarasa*) with poetic expressiveness.

No less impressive for their assured handling of form are the other objects from Nepal. A complex lamp (no. 42), rich in symbolism, is a deft combination of various forms, and the two Bhairava heads (nos. 43–44) are

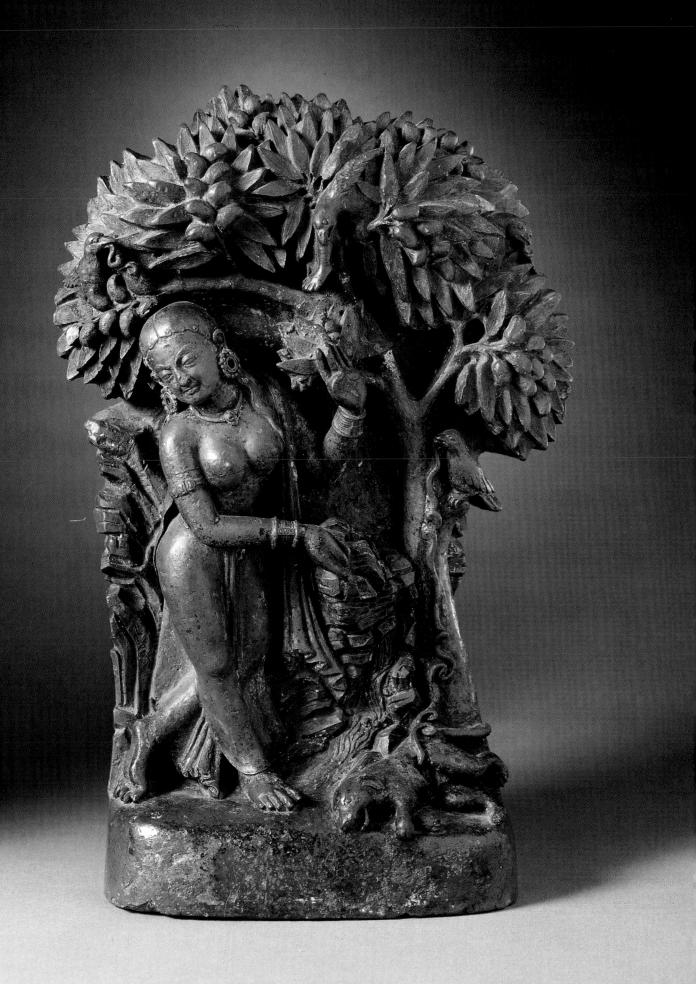

outstanding examples of a type of object unique to Nepal. To date no prototypes for such wonderfully expressive masklike Bhairava heads have been found in India, so that one can unhesitatingly consider these to be manifestations of the rich Nepali imagination. The rituals for which they were used are also peculiar to Nepal. The seventeenth-century Nepali image of Vaiśravaṇa (no. 45), the divine regent of the North, exemplifies the growing influence of Tibetan iconography on Nepali Buddhist art. The garments and flaming aureole of this articulately modeled guardian figure are wonderfully crisp and vibrant. The same sensitive craftsmanship and attention to detail characterize the slightly later Tibetan representation of the cosmic form of Avalokiteshvara and an elaborately conceived and arranged mandala of Vajrayana deities (nos. 46–47). Whether modeled by Tibetan or Newari artists from Nepal, they are very fine examples of the continued vitality of the Tibetan terra-cotta tradition.

Only a few specimens of the rich array of Javanese terra-cotta included here were made for devotional use. One is a terra-cotta head of the Buddha (no. 27), a unique early Javanese example. Buddhist images are extremely rare among Majapahit-period terra-cottas. The impressive figure of a bodhisattva in the collection (no. 38) is not only of enormous cultural significance but a remarkable work of art. Despite the large corpus of Majapahit terra-cotta, few represent clearly identifiable gods and goddesses, either Hindu or Buddhist. While Ganesa's identity is in no doubt (no. 39) and a four-armed female certainly portrays a goddess (no. 40), other objects too may well have had some religious association (nos. 13–14). What is significant is that, whether religious or secular, Majapahit terra-cottas reveal a coherent style distinctly different from that which prevailed earlier in Central Java. Not only are the differences pronounced in the recognizably varied and expressive ethnic features of the figures but also in their ornamentation and slender proportions. Invariably they are smoothly finished, and much attention was given to the simple, but elegant garments that subtly enhance the volume of the figures. An unusual Javanese object in the collection is the impressive and complete model of a temple, which may have served a funerary function (no. 37). Remains of the dead after cremation may have been deposited in such structures and then worshiped. Until the richly varied, but little-known corpus of Majapahit terra-cottas is studied further, such suggestions must be regarded as largely conjectural.

## Images of Whimsy

Because terra-cottas have a broader constituency than sculptures made specifically for temples and because artists who made such objects enjoyed greater freedom than sculptors responsible for temple sculptures and bronze icons, by and large terra-cottas are more intimate and expressive. Not constrained by iconographic injunctions and stringent theories of proportions, the artists who worked in clay freely created an astonishing variety of shapes and forms, ranging from the highly abstract to the delightfully naturalistic. Terra-cotta was the principal medium with which artists created objects of everyday use, and except for ordinary pots and plates, most items were enlivened with a sense of whimsy and playfulness, often intended to amuse and sometimes even intrigue the viewer.

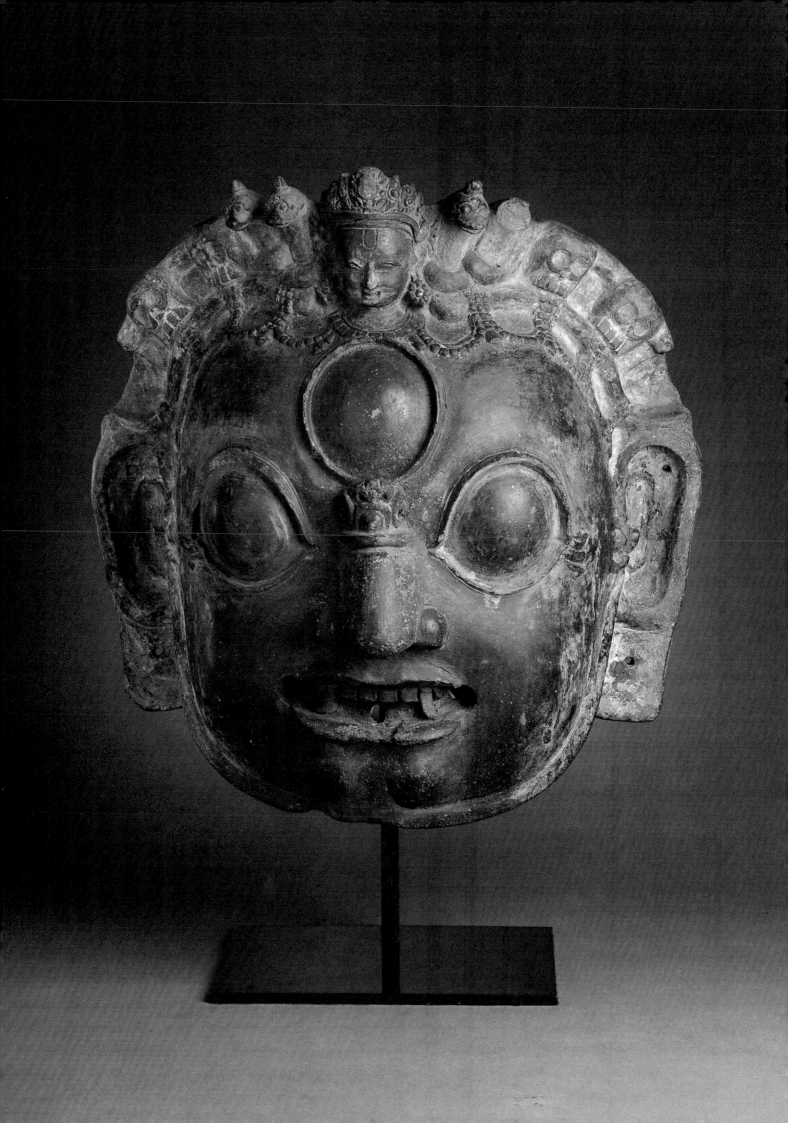

Among the everyday objects in the collection are a group of animals from early India, some of which were probably used for religious rituals or as toys (nos. 50–54). The three elephants from Pakistan, India, and Sri Lanka reveal how artists created quite different, but equally charming representations of this much-loved animal. The elephant was not the only animal especially popular with children in ancient India and Southeast Asia. The collection also includes a toy horse and ram and a model chariot drawn by bullocks. Indeed, from all over northern India have been discovered enormous quantities of terra-cotta toys dating from the Harappan civilization. Even in my childhood in the late 1930s clay and terra-cotta toys were available in metropolitan areas such as Calcutta, and the most desirable were those made by the potters of Krishnanagar not far from the city.

Ancient literature confirms the archaeological evidence by frequently mentioning terra-cotta toys of a wide variety. An important Sanskrit play is entitled *Mṛichchhakaṭika* (The little clay cart) by Sudraka (active fourth century). The son of the hero of the story is upset when his father, not being able to afford extravagant luxuries, gives the boy a clay rather than a gold cart. More important than such references is a large section of the *Kāśyapasaṁhitā,* which not only provides a long list of such toys but also informs us that they were an essential part of the rice-eating ceremony performed usually in the sixth month after a child's birth.[23] To ascertain a child's future interests, a baby was encircled by a manifold variety of objects and was allowed to crawl among them and make a selection. (This rite is still performed by Hindus in India and elsewhere). Apart from such items as gold and silver, also included in the circle were milk and honey as well as books and toys. The latter consisted of miniature animals and various forms of transportation, such as model chariots and boats.

Concern about the safety of children was also voiced by the authors of ancient Indian medical treatises. Both the *Kāśyapasaṁhitā* and better-known *Charakasaṁhitā* of the same period categorically state that toys "should be well polished, handy, straight and easy to move from place to place, charming and sound-producing. . . . They should be pleasant looking, have soft edges and should be such that they could not be easily put into the mouth or swallowed by a child."[24]

Animals and carts are not the only items included in the list of toys provided by these medical texts. The *Charakasaṁhitā* describes a variety of clay and terra-cotta dolls also intended to educate the child. These dolls were named after words denoting various family members, such as "daughter," "son," "sister," "brother," "aunt," "uncle," and others.[25] All too often scholars identify the beautiful terra-cotta figures of early India indiscriminately as mother goddesses. Some are so urbanely stylish that one wonders if they were not meant to be dolls. The elegant representation of a noble lady, probably from the Patna region in Bihar, may well be a doll depicting a rich aunt (no. 68).

Textual evidence clearly states that terra-cotta figures were used extensively for decorating the home. Apart from general references to beautiful female figures used as dolls, Jaina literature specifically describes how the art gallery of a banker was decorated with both solid and hollow terra-cotta dolls. That clay figures were used in weddings is known from the *Harshacharita* (Life of Harsha) by the great poet Bāṇabhaṭṭa (active seventh century). On the preparation of the royal wedding, the poet wrote: "Multitudes of modelers molded clay figures of fishes, tortoises, crocodiles [makara], cocoanuts, plantains and betel trees."[26] These objects symbolize auspiciousness, and while the tortoise and makara are not generally

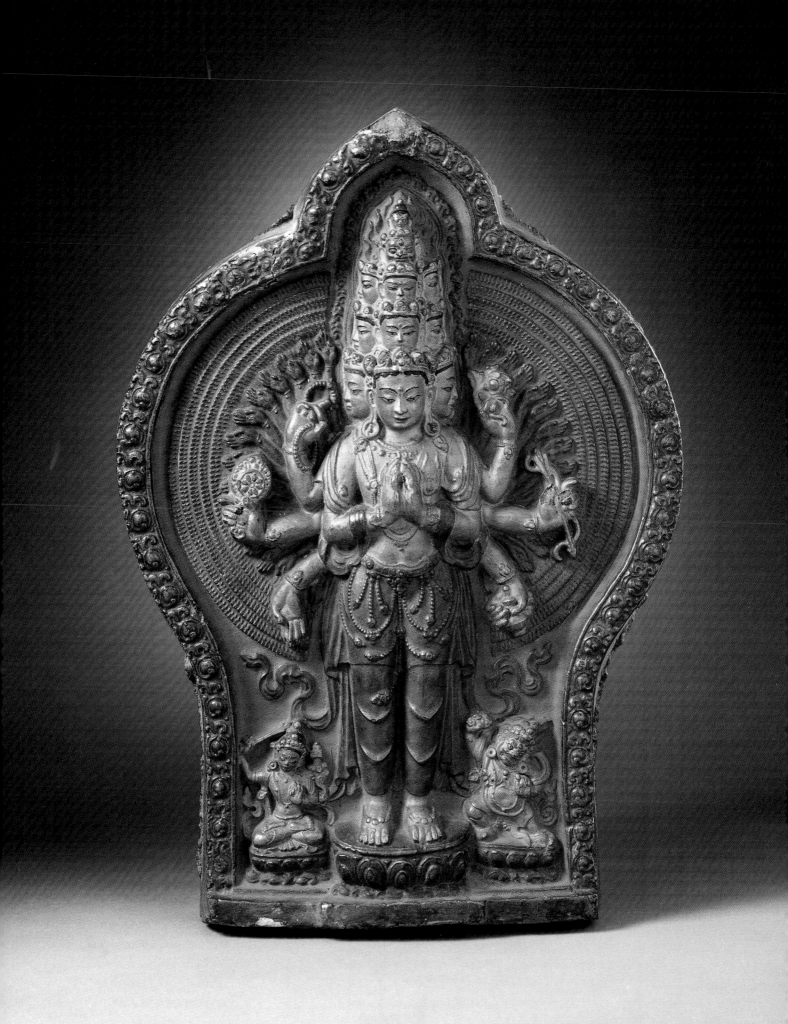

encountered in Hindu weddings today, the coconut, plantain, and betel are still essential ingredients. A pair of fish, symbol of fertility, is indispensable in Bengali weddings. One wonders if the plaque with a lady holding a pair of fish (no. 4) could have served the same function. While some artists at the royal wedding in the *Harshacharita* were busy modeling, others were engaged "in leaf and plant painting to adorn polished cups and collections of unbaked clayware." Unbaked clay cups are still used widely in India for beverages, and until recently it was customary at weddings to serve meals on leaves, whether banana or sal, and beverages in clay cups and tumblers. The affluent used polished cups, and these utensils may have been decorated with paintings for the wedding of a princess.

Describing the decoration of the wedding hall, Bāṇabhaṭṭa wrote: "Gleaming around it were earthen dolls whose hands bore auspicious fruits, and which have five-mouthed cups . . . [and] faces painted with soft colors."[27] A recent exhibition of the living arts of India included a contemporary papier-mâché doll that fits this description almost verbatim.[28] Obviously large statues made of unbaked clay and terra-cotta were used to adorn palaces, especially for weddings and other ceremonial occasions. This is also confirmed by Varāhamihira in his *Bṛihatsaṁhitā,* where in a section devoted to weddings (*Vivāhapaṭala*) he refers to the "employment of expert sculptors for fashioning clay figures."[29] As late as the nineteenth century in Calcutta clay figures of various mythological personalities, as well as Shakespearean characters (under British influence), were used to decorate the sacred area during the annual worship of the goddess Durga.

Among the most popular themes represented in Indian art is that of a couple shown in dalliance, known in Sanskrit as a *mithuna* (no. 69). The representation of such a couple is considered to be an auspicious symbol of conjugal bliss, harmony, and completeness. While some of these plaques may have had ritual significance, one wonders if some were not meant for distribution at wedding ceremonies. What other occasion could be more appropriate for the display of such plaques? While most such Indian representations are in the form of plaques, an artist in East Java created an astonishingly lively, three-dimensional example of a couple engaged in dalliance (no. 80). Although its exact function is not known, it is remarkable for its expressive realism.

Other utilitarian terra-cotta articles were seals used by bureaucrats and administrative officers. While the seals themselves were often made of metal, they appear to have been frequently impressed into clay. One such seal impression (no. 25) represents a well-known type used by the governor's office in the ancient city of Vaiśālī (Basarh in Bihar), an important administrative center in the Gupta Empire. The function of such seals was purely secular, but the symbols engraved on them were often religious. Seals also were employed by important Buddhist monasteries in India, each having its individual insignia.

Many human figures may have been attempts at portraiture. Certainly the well-modeled head from Akhnur in Jammu (no. 73), with its particularized facial features and distinctive hair arrangement belonged to a portrait of an important donor as may also have been the case with another Indian head (no. 71). A small head from Sri Lanka is particularly expressive and may well have been modeled after an individual (no. 74). Representations of kings and donors in stone and bronze in South and Southeast Asia were often idealized to such a degree that they are rarely expressive of the actual physical features or personality of the individual, as may be seen in terra-cotta representations from both Thailand and

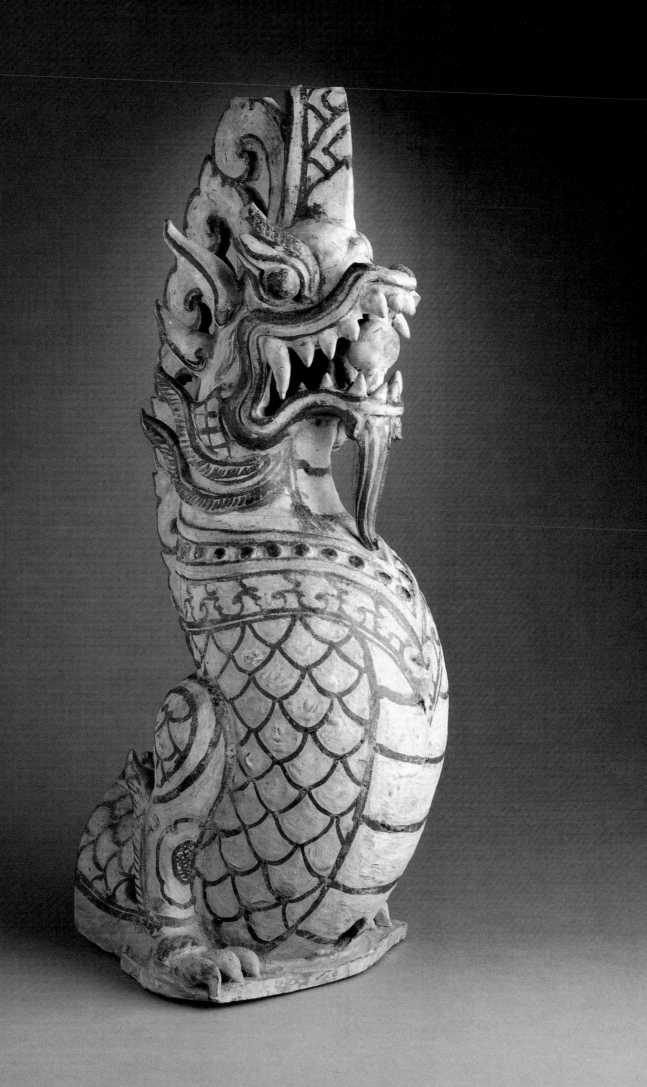

Java (nos. 36, 77); indeed these are depictions of deified mortals. Not infrequently, however, terra-cotta figures, especially in Majapahit-period East Java, reflect highly individualized features that are clearly the result of direct observation.

While the sudden burst of terra-cotta production in the Majapahit Kingdom remains an enigma and little is known of the function of the wide variety of objects discovered from the capital city of Trawulan, the products themselves are most engaging for their virtuosity and decorative exuberance. Whether or not inspired by the Chinese aesthetic, Majapahit terra-cottas are quintessentially Javanese and are often remarkable as much for their original designs as for their humorous shapes. Javanese artists were equally deft in modeling figures of delicate, petite, and graceful women and in depicting highly amusing characters undoubtedly meant to be caricatures. The sophistication and urbane charm of these figures are surprisingly reminiscent of the brief period in Maurya India when the artists of Pataliputra (modern Patna in Bihar), the capital of the empire, produced some of the most vivacious and elegant terra-cotta figures in the round. While the sculptors in the Maurya capital may well have been influenced by Greek terra-cotta figures, such as those from Tanagra, just as more certainly their colleagues in the coastal Sātavāhana Empire during the first two centuries of the Christian era were influenced by Roman figures, no such foreign influence can explain the rich diversity and aesthetic ingenuity of the Majapahit tradition.

The two impressive sculptures of a fat man and a plump woman with pendulous breasts may well be caricatures of well-known personalities (nos. 78–79). The fat man may represent a dwarf, perhaps a court jester, and by depicting him in an almost impossible posture that emphasizes his girth, the artist has made the portrait an object of both pathos and amusement. Equally perceptive is the representation of the formidable woman with her wonderfully expressive face. This sense of playfulness and wry humor is also evident in the depiction of a monkey (no. 63), which should delight a Freudian analyst with its obvious erotic overtones. The erotic flavor is less overt in the numerous delineations of fragile and wistful women (no. 82).

No less exciting are the animal forms modeled by Majapahit artists. While some are the result of the artists' keen observation (nos. 60, 62), others are astonishing creations of whimsy and imagination (nos. 57–59). Some creatures, such as the composite naga, the makara, and the cockerel certainly served architectural functions. Majapahit artists delighted in creating unusual terra-cotta forms to adorn their wood and bamboo structures. One of the most fascinating objects in the collection is a shallow bowl embellished with a three-dimensional representation of an upside-down hawk (no. 58). Whatever its purpose, it is a highly original composition admirably demonstrating the artist's assured handling of material to mold a boldly conceived design.

Among the most whimsical of all terra-cotta objects created by Majapahit artists are coin boxes. The most engaging are those modeled in the shape of a pig (no. 62). The example in the collection is not only well preserved but is one of the finest of such piggy banks. They apparently were used to store Chinese coins, and the custom may have been introduced by Chinese settlers and tradesmen in the fourteenth century. The pig is considered to be a symbol of wealth in China; nothing quite like these coin boxes, however, is known in China. Moreover, the sudden demand for money boxes in the Majapahit Kingdom has not been satisfactorily explained. There are no precedents elsewhere in Java, and the practice seems to have

lost its popularity during subsequent centuries. While the pig is not the only creature to have been used for Majapahit money boxes, it was certainly a favorite subject. One wonders if the now-familiar piggy bank in the West does not reflect a borrowing from the residents of Majapahit or China. The Dutch, who later colonized Indonesia, or other early European travelers may well have introduced such banks to Europe. Although terra-cotta money boxes had been known on the Continent since Roman times, the penny bank in the shape of a pig did not make its appearance in the West before the sixteenth century.

It would be wrong to presume that only objects with secular functions reflect the sense of whimsy that distinguishes the terra-cotta tradition from other sculptural forms. The Indians often informed their animals with human qualities, whether the object was a toy or votive offering. The Kushan-period trio of monkey musicians (no. 56) is certainly amusing, even if it may have served a religious function. Similarly the unknown craftsmen of Sri Lanka responsible for the strange fertility figures (nos. 10–12) seem to have deliberately instilled these votive objects with a comic flavor. And the fifteenth-century Burmese artists clearly preferred to make their demon creatures humorous rather than terrifying, even though they were meant to adorn religious edifices.

Expressing spiritual aspirations as well as flights of fancy, humble clay has remained throughout the ages an astonishingly versatile material in the hands of the unknown artists of South and Southeast Asia. Although they have not received the attention they should, terra-cotta sculptures often reflect a sense of whimsy and spontaneity not always encountered in sculptures intended for temples and monasteries.

**Notes**

1. The jibe of an early twentieth-century scholar at Oxford is quoted from Godakumbura, n.d., p. 21.

2. Those who are interested in a discussion of the making of terra-cotta sculptures may consult Poster 1986.

3. See Singer 1972 for an analysis of Redfield's theory as well as bibliographic references.

4. Singer 1972, p. 55.

5. See Dhavalikar 1977 for a discussion of Sātavāhana terra-cottas and also for a general introduction to the history of Indian terra-cottas. See *Aditi* 1985, p. 18, for recent monumental terra-cotta images of rural protective deities in southern India. Also p. 38 for first millennium B.C. figures from the south that bear remarkable resemblance to those from the northwest.

6. Allchin and Allchin 1982, pp. 208–9. This is a good introduction to prehistoric Indian pottery and terra-cottas.

7. Whitney 1962, p. 421.

8. Shende 1952, pp. 162–63.

9. Rau 1974, pp. 137–42.

10. See Allchin and Allchin 1982 for a review of the material. The pottery found in graves near Peshawar as well as in Dir and Swat is also fascinating. If these graves belonged to early peoples of Indo-European origin, then they would confirm some use of terra-cotta images by the Vedic Aryans.

11. For a discussion of the terra-cotta art of the second urban phase of Indian civilization, see Gupta 1980.

12. See Pal 1974, p. 25; Slusser 1982; and Pal 1985 for examples of early Nepali terra-cottas.

13. See Frasché 1976 and Stratton and Scott 1981 for Thai ceramic and terra-cotta art.

14. Muller 1978 and Nieuwenhuis 1986.

15. Various examples of ceramic ware were also imported into Indonesia from mainland Asia.

16. See *Aditi* 1985, p. 117, for a contemporary example from West Bengal. Also illustrated (p. 49) is a pair of figures representing Siva and Parvati carried on the heads of women during a Gangaur festival in Madhya Pradesh. A star-shaped baby, like those clinging to the Pakistani figure (no. 8), is similarly attached to the bosom of Parvati in these festival figures.

17. See Tiwari 1985 for a review of the various theories and for bibliographic references. See also the chapter on terra-cottas in Gupta 1980 and Desai 1975.

18. Tiwari 1985, p. 5.

19. Ibid.

20. Lal and Dikshit 1978–79.

21. Mitra Shastri 1969, pp. 308–9.

22. See Poster 1986, pp. 156–60, nos. 94–98. Interestingly three of the panels are inscribed, and since inscribed panels of the *Ramayana* have so far only been found in Nacharkhera in Haryana these panels may also have emerged from that site. In two panels the multiarmed male is identified clearly as Vena (nos. 96–97), and yet the author identifies him in one instance (no. 96) as a charioteer and in the other as Siva (no. 97).

23. Shah 1956.

24. Dhavalikar 1977, pp. 2–3.

25. Ibid.

26. Cowell and Thomas 1968, p. 124.

27. Ibid., p. 130.

28. *Aditi* 1985, p. 32.

29. Mitra Shastri 1969, p. 309.

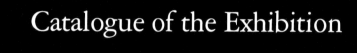

Catalogue of the Exhibition

# Icons of Piety

## Fertility Figures and Symbols

*1*   *Goddess*
India, Uttar Pradesh, Mathura;
third century B.C.
Gray-black terra-cotta; 8 1/2 in (21.5 cm)

Although the armless figure lacks parts of her legs and headdress, she is a typical example of the luxurious gray-black terra-cotta female figures popular in Mathura during the Maurya period (321–187 B.C.). Characteristic of such figures are stumpy arms and legs; wide, flaring hips adorned with elaborate, applied girdles; disproportionately large hoop ear ornaments; and remarkably prominent, complex headgears framing a small face. Her facial features are well articulated, and a circle, or dot, is added between the eyebrows and also on the right cheek. Ribbons of clay encircle the high, pointed breasts and are applied as braids of hair and ornaments at the sides of the body. Immediately above the shallow navel is a cylindrical object, which may be a container for charms. In contrast to the front, the back is summarily modeled.

      While the exact identification of such figures cannot be determined, they are generally identified as fertility goddesses. Their function too remains a mystery, for none has so far been found that can stand by itself or has a

base. Thus, it is unlikely that the figures stood in domestic shrines as the foci of cultic practices without support from the back. A support would also have been necessary if they were used as decorations. Whatever their exact function, the prominence of the breasts and hips certainly indicate that they are symbols of fecundity and abundance.

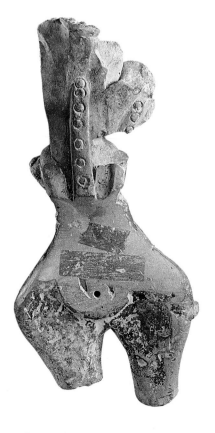

### 2    *Baroque Lady*

Pakistan; second century B.C.
Reddish brown terra-cotta with traces of black
pigment; 5 1/8 in (13.0 cm)

This figure represents a fine example of a type of
small female image that remained extremely
popular in the Indus Valley in Pakistan for more
than two millennia. Although this particular
example is closely related to hundreds of such
figures found from various excavated sites
(Marshall 1951 [1975], pl. 132, nos. 1–5; Dani
1965–66, pls. XXIV–XXVIII), it differs in minor
ways from those examples. The strange
proportions, triangular lower half, tiny pellets
for breasts, and pinched face with applied
cowrie-shell eyes are characteristic of these
figures. In most such examples, however, incised
lines demarcate the waistline and legs and
embellish the calves. In this figure no such
incisions are visible. Instead, traces of painted
black parallel bands are discernible around the
broad hips and prominent buttocks.
Furthermore, unlike other examples, the figure
does not wear a torque, but a crossbelt is painted
in black across her torso. Similarly painted
crossbelts are also faintly visible in a fragmentary
example discovered in Shaikhan Dheri, near
Peshawar, in ancient Gandhara (Dani 1965–66,
pl. XXVII, no. 2).

The exact identification of such
figures is not known, but undoubtedly they
represent important local goddesses associated
with fertility and abundance. Described first as
"baroque ladies" by Mortimer Wheeler, most
were recovered from a stratum datable to the
third–second century B.C., a period coinciding
with the Indo-Greek presence in the region.

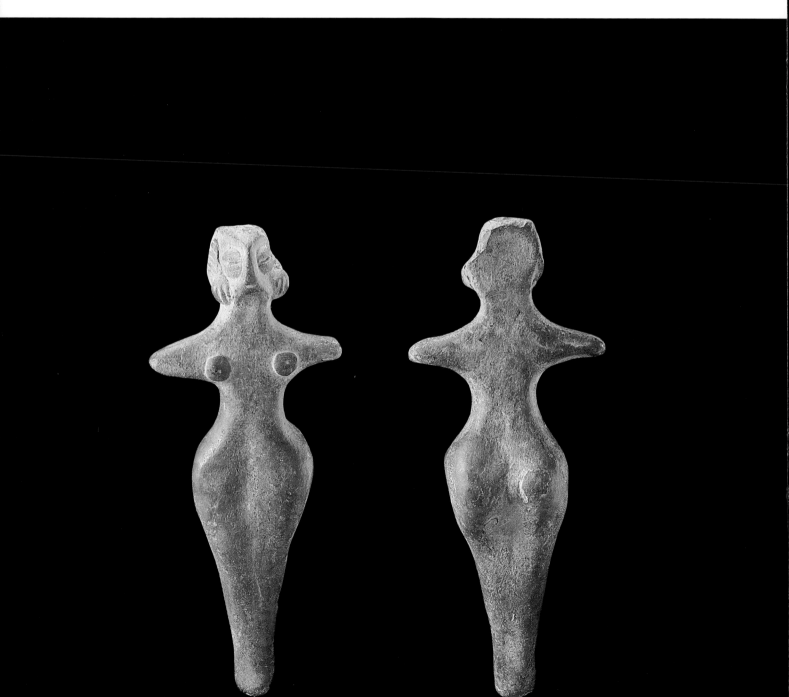

*3   Goddess of Abundance*
India, Uttar Pradesh, Kausambi;
second century B.C.
Red terra-cotta; 9 3/4 in (24.8 cm)

An almost identical plaque recovered from
Kausambi (present-day Kosam) is in the
Allahabad Museum (Kala 1980, p. 15, fig. 21).
The slight difference in size between the two is
negligible, and almost certainly both plaques
were made from the same mold. Each has a hole
at the top, indicating that it probably was hung
on the wall of a household shrine. Their
remarkably well-preserved condition
demonstrates that such terra-cotta images
probably were not handled while in use.

The lady with splayed feet
stands frontally on a lotus. Her ample
proportions recall the contemporary larger-than-
life stone images generally identified with
yakshis (nature spirits). She is, however, much
more richly attired and ornamented than the
stone figures. She does not appear to hold any
attribute in her hands, which hang down on
either side with the fists closed. Her two most
distinctive features are the long braids of hair
that fall to her hips and the elaborate headdress.

Such headdresses, consisting of five sheaves of
corn on the left and five symbols on the right,
are characteristic of this type of figure found at
many sites across northern India. Among the
objects on the right, a battle-ax and elephant
goad are clearly recognizable.

These attributes, together with
her placement on the lotus and hieratic, frontal
posture, clearly announce her divinity. Her exact
identification, however, remains enigmatic. She
has been variously identified as a yakshi, the
apsara (water spirit) Pañchachūḍā (five-crested),
or the goddess Sri-Lakshmi. That she is a
goddess of abundance is clear enough, but the
inclusion of the weapons in her headdress would
also make her a martial deity. Conceptually she
may well be a prototype of the later Indian
goddess Durga (nos. 15–16), who is worshiped
as a deity of abundance and victory.

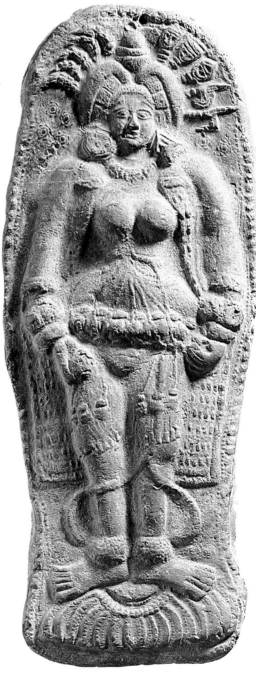

4   *Goddess with Fish*
India, Uttar Pradesh; c. 100 B.C.
Red terra-cotta; 6 1/8 in (15.5 cm)
Gift of Marilyn Walter Grounds; M.83.221.2
Literature: Pal 1986, p. 137, S16.

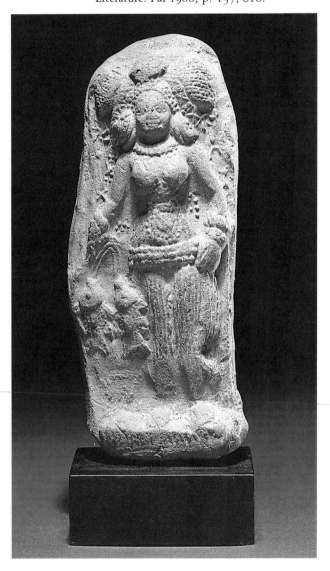

A female holding a pair of fish is a common
motif among terra-cottas of this period and is
known from Mathura, Kausambi, and
Chandraketugarh, northwest of Calcutta. The
figure has been variously identified as the earth
goddess Vasudhārā and the Indian counterpart of
the Iranian goddess Anahita (see Literature). The
fish is an ancient Indian symbol of abundance
and fertility, and a pair (*mithuna*) is considered an
auspicious emblem of conjugal bliss. Although
her exact identification remains a mystery, that
she is an Indian goddess of abundance, whose
cult was popular across a wide area of the north
Indian riverine plains, is evident. As is usual
with such molded plaques of this period, the
goddess is richly attired and ornamented.

5   *Mother Goddess*
India, Uttar Pradesh; second century
Reddish brown terra-cotta; 19 in (48.3 cm)
Literature: Dehejia 1986, p. 23, fig. 17.

Except for the head, this cult image is
remarkably well preserved and smoothly
modeled. It is also exceptionally large for terra-
cotta figures of the Kushan period (50–200).
Exposing her prominent breasts and clad only in
a lower garment, the figure sits imperiously. Her
long, slender arms are profusely adorned with
bangles, an ancient mode of adornment still
preferred by Indian women. The placement of
her feet and arms as well as her posture imparts a

sense of dignity and self-confidence. She holds a
bowl in her left hand; the object in her right
hand, perhaps a blunt weapon of some kind,
cannot be readily identified.

Very likely she represents a
mother goddess (for more complete examples see
no. 7 and Pal 1986, pp. 190–91, S68). While
during the Gupta period (320–600) the mother
goddesses known as Mātṛikā were specifically
identifiable and their images were carved in
stone, during the Kushan period their
identification was ambiguous and their images
in terra-cotta were more popular. The posture
and bowl appear to have been common attributes
of such Kushan-period mother goddess figures.

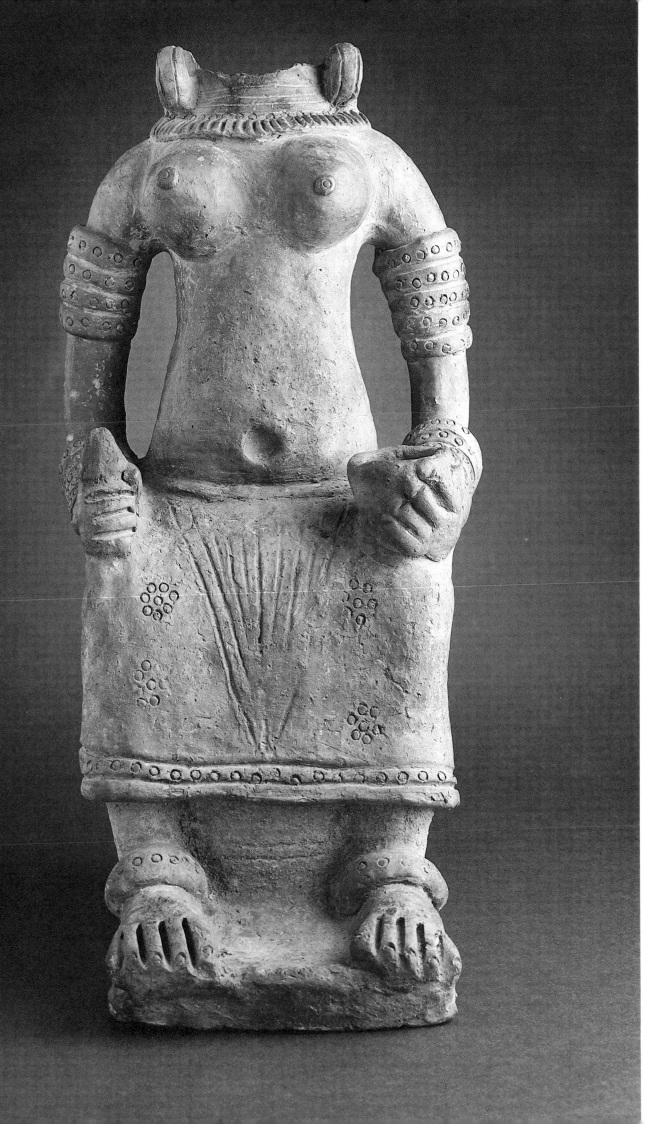

*6a–b   Male and Female Figures*
India, Maharashtra, Ter; second century
*a,* kaolin; 4 1/4 in (10.8 cm)
*b,* red terra-cotta; 3 3/8 in (8.5 cm)
Literature: *a,* Dehejia 1986, p. 223, fig. 16.

The kaolin male (*a*) and terra-cotta female (*b*)
figures are stylistically related to similar figures
recovered in hoards from Ter, near Osmanabad,
Maharashtra, although similar figures have been
found in large numbers in Andhra Pradesh as
well (Poster 1986, pp. 114–15, nos. 46–48).
Known in ancient times as Tagara, Ter was a very
important trading center in this region during
the Sātavāhana dynasty (first century B.C.–third
century A.D.). Most such sculptures, made of
either kaolin or terra-cotta, are distinguished by
their rather plump and stocky proportions,
nudity, heavy jewelry, peculiar squatting posture
without the support of a seat, and distinctive
hairstyle.

  The male figure, perhaps
representing a yaksha, holds a bunch of fruit in
his right hand; a bird is perched on his left arm.
These attributes appear to be quite common to
both male and female figures, who in some
instances, such as this, seem somewhat boyish.
The fruit may well be the mango, which later
became an important attribute of the Jain
mother goddess Ambikā. The bird is a common
attribute in early Indian terra-cotta art,
especially for boys (Pal 1986, p. 143, S23, for an
example from West Bengal).

  The female, more summarily
rendered than the male, does not hold any
attribute but is distinguished by the elegant
arrangement of her hair. Both figures wear their
long hair down their backs, and wide girdles
loop around their clearly delineated buttocks.
The figures have wide, staring eyes. Curiously
the mouth of the female seems not to have been
formed and is indicated by a simple rectangle.
(For similar figures from Ter see Gorakshakar
1975, pls. 28, 62–63.)

  Usually such figures were made
from two molds joined together, a technique said
to have been introduced by the Romans. The
style of the figures, however, owes nothing to
Roman models. More intriguing is the function
of such figures. Were they cult images? If they
were used in domestic shrines, were their seats
made separately? Or were they offered at shrines
as votive objects? Or were some of them simply
used for decorative purposes? Even if they were
used religiously, they display a sense of whimsy
and may well have been produced simply to
satisfy the aesthetic needs of the sophisticated
citizens of the Sātavāhana Empire.

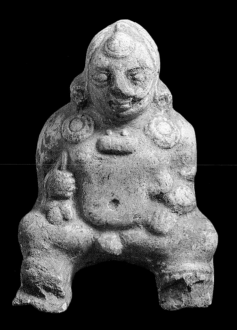
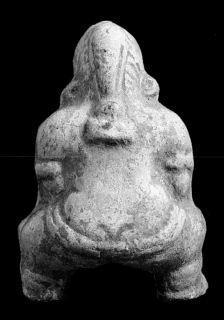

6a

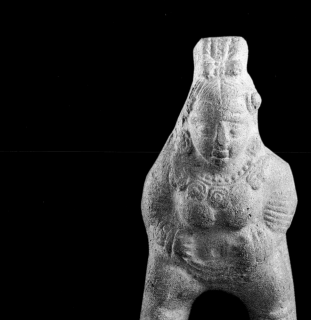
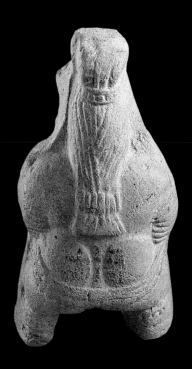

6b

7    *Mother Goddess*
India, Uttar Pradesh; second century
Buff terra-cotta; 12 3/4 in (32.4 cm)
Gift of Marilyn Walter Grounds; M.83.221.5
Literature: Pal 1986, p. 197, S74.

Although not as large as the similarly seated
goddess in the collection (no. 5), this is a more
complete example. With her head thrown back,
the goddess sits frontally on a stool. She holds a
cup in her right hand and rests her left hand on
her knee. As in the other figure, her right arm is
covered almost entirely with bangles.
    Aesthetically the two figures
differ considerably. This image is more coarsely
modeled and not as finely proportioned. Her
broad facial features, with high cheekbones and
recessed mouth, seem somewhat dispropor-
tionate. This lack of concern for anatomy is also
evident in the unnatural placement of the deep
navel and rather elongated legs. Nevertheless,
the representation has a power and savage
dignity appropriate for a goddess of dread. (For a
similar figure with a child recovered from a tank
in Sringaverapur, Uttar Pradesh, dated to the
first century, see *Aditi* 1985, pp. 1, 4.)

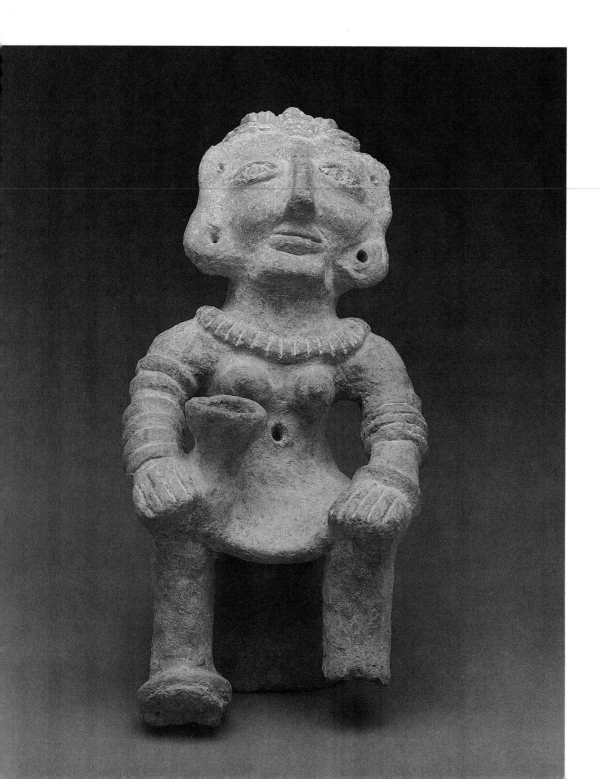

8   *Mother Goddess*
Pakistan, near Mardan; first millennium
Pinkish red terra-cotta; 6 1/4 in (15.8 cm)

Several such figures are said to have been found near Mardan, northeast of Peshawar. In addition to their strange avian heads and wings, they are also distinguished by the curious manner in which several small, abstract figures of children are attached to their bodies. Some, such as this example, seem also to have four arms with crudely rendered hands and wrist bangles. Whether the figure is clothed cannot be determined, but she does wear a necklace and tiara. With her left hand she presses the head of a child against her breast. Wavy strands of hair fall down her shoulders in front and back.

Stylistic parallels for this and the following figure (no. 9) are offered by finds in Shaikhan Dheri and Damkot, in the Swat Valley. The Kushan level at Shaikhan Dheri has yielded a fragmentary terra-cotta figure with an almost identical avian face (Dani 1965–66, pl. xxxiii, no. 4) and several monkeys that are comparable in technique (ibid., pl. xxxviii). The eyes of the monkeys, consisting of large circles with a pinpoint dot for the pupil, are identical to those of this mother goddess. Comparable also are a male and female figure excavated from later levels at Damkot (Rahman 1968–69, pl. 88b–c).

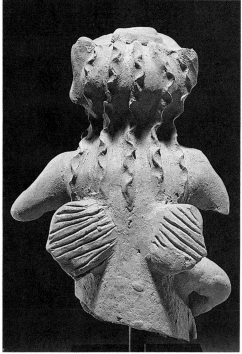

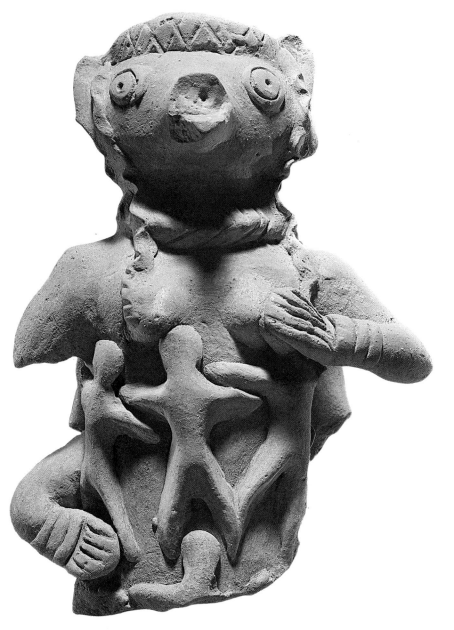

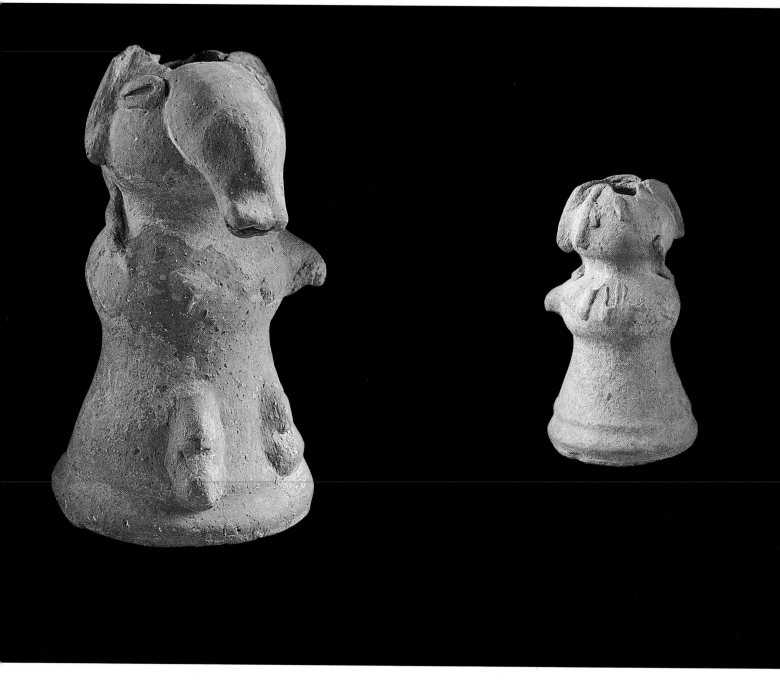

**9    *Elephant-headed Figure***
Pakistan, near Mardan; first millennium
Pink terra-cotta; 6 1/2 in (16.4 cm)

Although the trunk is somewhat short, the
modeling of the head shows the artist's
familiarity with the elephant. The hollow
cylindrical body has been shaped by pinching the
waist to suggest an abstracted human figure.
Only one stumpy arm remains on the left, the
legs are indicated by small protrusions. The two
pellets attached to the chest may represent
female breasts. The long strands of hair at the
back may also indicate that the figure is meant to
represent a female. Like the hair, the cowrie-shell
eyes and the arms were separately attached. The
top of the head is broken, and the surface is
encrusted with lime deposit.

If the figure is a male, then it
may be a folk representation of the elephant-
headed god Ganesa (no. 26). If it is female, then
the figure must be regarded as an elephant-
headed goddess. Like the companion example
from the Mardan area (no. 8), it too probably is a
votive fertility object. Stylized, abstract terra-
cotta figures with cylindrical bodies have
remained popular in many parts of the subconti-
nent (Poster 1986, nos. 128, 130) and in Sri
Lanka (no. 10a–b). Rarely is the form as sophis-
ticated and elegant as is this elephant-headed
figure. (For a fragmentary lion-headed figure
that may have had a similar hollow body found
in Damkot, see Rahman 1968–69, pl. 90b.)

10a

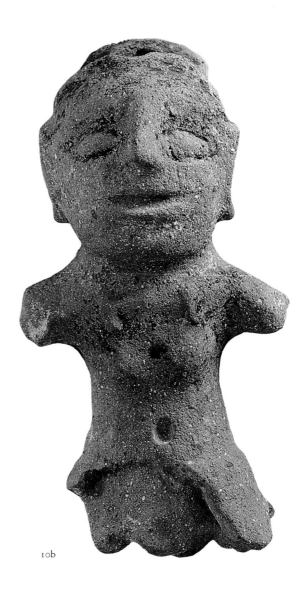

10b

*10a–b   Two Fertility Figures*
Sri Lanka; first millennium
Red terra-cotta with traces of black pigment;
*a,* 6 1/2 in (16.4 cm); *b,* 7 1/2 in (19.0 cm)

Although their proportions differ, both figures very likely represent females and were used in fertility rituals. Their cylindrical shapes may represent phalluses, while their anthropomorphic features announce their female aspects. Thus, in modeling such objects the artist may well have combined both sexes. The breasts are much more prominent in the narrower figure (*a*). Both, however, have deep navels and stumpy arms. Pellets have been attached to the neck to indicate necklaces, otherwise the figures are quite unadorned. The face is much more abstractly modeled in *a* with a protrusion serving as a mouth, two holes indicating ears, and two irregular pellets serving as eyes. In *b* the features are more naturalistically modeled. This figure may also have been seated on a stool, and a large hole at the back of the head indicates that the object may have been suspended by a string.

Because the context in which these figures were found is not known, it is extremely difficult to be certain of their date. Somewhat similar cylindrical figures (no. 9) have been found in the northwest from the Kushan and later periods. The closest parallels for these Sri Lankan examples may be seen in several found in Karnataka in southern India (Poster 1986, p. 187, no. 128). With regard to these phallic types it has been suggested that "in terra-cottas the type that is usually of much antiquity are the phallic objects" (Goda-kumbura, n.d., p. 23).

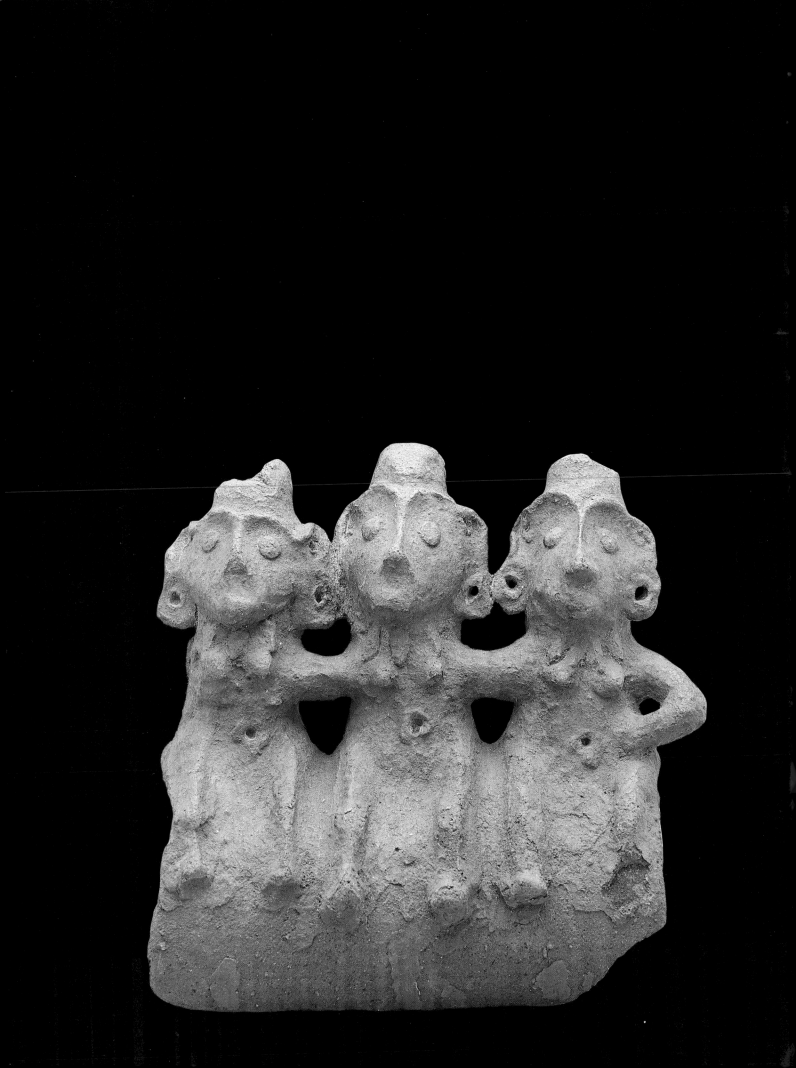

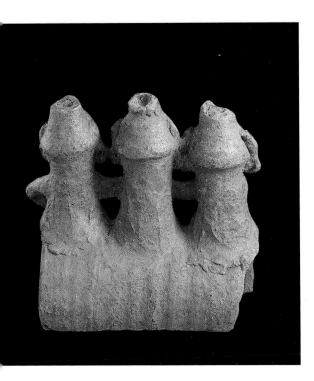

11 *Three Goddesses*
Sri Lanka; first millennium
Red terra-cotta with traces of black pigment;
9 1/4 in (23.4 cm)

Seated with their legs outstretched and arms
linked, the three figures form a charming group,
expressing an intimate unity. Perfunctorily
modeled, like the so-called phallic figures (no.
10a–b), these ladies have more fully formed
limbs. Their anatomy is distinguished by a
prominent navel, small breasts, and large,
pierced ears. Stylistically they are related to
fragmentary heads found in the Kilinochchi
region (Godakumbura, n.d., pls. 3, 5). In fact,
this is one of the most complete examples of such
terra-cotta votive objects from Sri Lanka.

       That the three figures represent
a triad of fertility goddesses is a reasonable
assumption. Such goddess triads continue to be
worshiped in Indian villages, and the cult is
quite ancient (Kosambi 1962). The Hindu god
Siva himself is said to have had three mothers.
Rather unusual is the barrel-shaped seat. It
would appear that the object was meant to en-
close a bamboo or wood rod.

12    *Animal-headed Figure*

---

12 *Animal-headed Figure*
Sri Lanka; first millennium
Red terra-cotta with traces of black pigment;
7 3/4 in (19.6 cm)

Like the three goddesses (no. 11), this too is a
remarkably well-preserved object. The function
and identification of the strange figure, however,
are baffling. The body is conceived as a hollow
cylinder, and the head is distinctly that of an
animal. The figure's four legs dangle in front
like flayed skin, partially covering the large
chest cavity. The bottom of the cylindrical body
is open. One wonders if it was used as some sort
of a lid, perhaps for an incense burner.

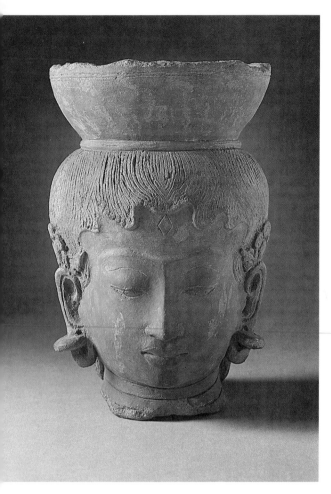

*13   Female Head*
Indonesia, East Java; eleventh century (?)
Red terra-cotta; 8 5/8 in (21.9 cm)
Literature: Dehejia 1986, p. 223, fig. 19.

This is undoubtedly one of the most beautiful
terra-cotta sculptures to have survived from
Java. Not only is it striking for its rich red color,
but the exquisitely delineated face epitomizes
simplicity and elegance. The sculptor
responsible for the head was particularly adept at
modeling and has rendered the facial expression
and other details with delicacy and finesse.
Interesting details include an incised diamond
on the temple, floral ornaments above the ears,
and the graceful sweep of the hair at the back.
    The exact function of the head
is not known. Its hollow interior and flaring
crown may indicate that it once served as a pot.
The neck may have been attached to a pot or to a
human body in the shape of a pot. Similar
objects with wide, shallow dishes supported by
human heads are considered to have been vessels
for offerings or flowers (Thomsen 1980, pp. 37,
120, no. 133). Presumably the dish above the
head is not hollow as is this example. The head
may also have had an architectural function,
serving as a column base (Muller 1978, pp.
85–86). In any event, the combination of a pot
and a female has since ancient times signified
fertility (see no. 14).
    The only stylistic parallels for
this sensitively modeled object may be seen in
the reliefs adorning the bathing place con-
structed in 977 in Djalatunda, on the western
slope of Mount Penanggungan in East Java, and
two spout figures of uncertain provenance
(Bernet Kempers 1959, pls. 185–90). Indeed,
this head is remarkably similar to those in the
two spout figures. The distinctive coiffure of this
female head varies slightly from the hairstyle of
the male spout figure, which unfortunately was
destroyed in the *International Colonial and
Overseas Exposition* held in Paris in 1931. The
classic features of the face are quite different from
those seen in heads made during the Majapahit
period (1293–1478).

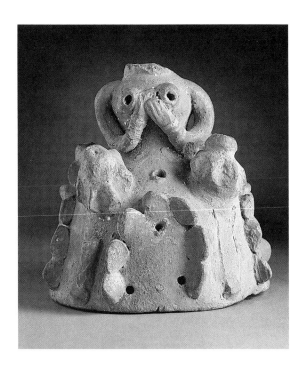 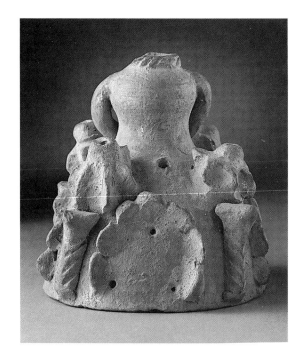

*14  Cover for Incense Burner*
Indonesia, East Java; fourteenth century (?)
Pink terra-cotta; 3 1/4 in (8.2 cm)

This charming object vividly demonstrates the Javanese sculptor's ingenuity for combining animated design with motifs charged with rich symbolism. The holes on the object clearly indicate that it was intended to be the cover of a censor. Terra-cotta censors are still widely used in India and must once also have been popular in Java.

The top of the censor is a pot shaped like a female with breasts and arms. Fragrant smoke would have been emitted from the tiny holes in the open neck and potlike breasts. At the four corners are four more pots placed on stylized lotuses (?) with a snake rearing its head below. Each of these pots also has an aperture at the top. Serpentine columns alternate with a floral motif with projecting petals.

The censor cover is rich in water and fertility symbols. The association of a woman and a pot, both auspicious symbols of life and abundance, is an ancient one in India and was also popular in Java. Female statues in bathing places often have water emerging from their breasts, as in Belahar, on the eastern slope of Mount Penanggungan, or from pots held between their breasts, as in the famous watering place at Goa Gadjah in Bali (Bernet Kempers 1959, pls. 204–5).

# Divine Forms
# and Sacred Objects

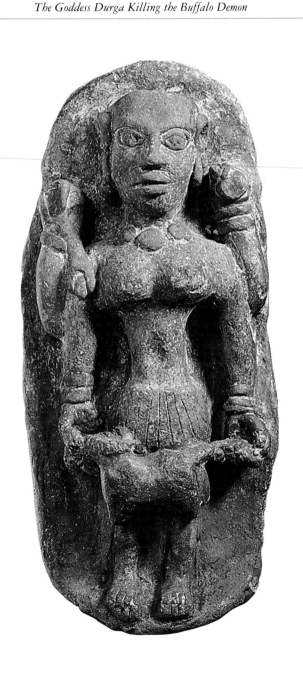

*15    The Goddess Durga Killing the Buffalo Demon*
India, Uttar Pradesh; third–fourth century
Reddish brown terra-cotta with black pigment;
9 3/4 in (26.7 cm)
Gift of Marilyn Walter Grounds; M.84.220.6
Literature: Pal 1986, p. 234, S109.

Both stylistically and iconographically, this is a unique representation of a popular theme frequently depicted in terra-cotta during the Gupta period. The subject is the well-known story of the goddess Durga destroying the buffalo demon. While in most Kushan-period reliefs the goddess appears to caress the buffalo, here she holds it by its head and tail as if she is about to give it a good spin and hurl the creature into oblivion. No other panel presents the combat in this manner.

Compared with the slightly later, although fragmentary representation (no. 16) this particular version is stylistically distinctive. The goddess is certainly not as attractive, and the details are much more casually rendered. While the Durga in the other relief is a graceful, even demure figure, here she is a stern personality exuding a sense of primitive vitality. Because of the figure's iconographic peculiarity and distinctive, formal characteristics, this plaque may well belong to the third–fourth century, before Gupta-period representations became conventionalized in the fifth century (see Poster 1986, p. 142, no. 77, for a similar coarsely modeled linga of about 300).

*16   The Goddess Durga Killing the Buffalo Demon*
India, Uttar Pradesh; fifth century
Red and gray terra-cotta; 6 1/2 in (16.5 cm)

Only the upper half of the plaque, modeled in high relief, remains, and it represents the goddess Durga as the destroyer of the buffalo demon (see also no. 15). The youthful goddess, who wears her hair pulled back into a bun and displays her full breasts, is engaged in killing the buffalo with her two lower arms, a common representation for such early figures. She holds a short trident with her upper-right hand. The object in her upper-left hand is not recognizable.

Although she is engaged in combat, the artist, as was customary, has portrayed the goddess as the very embodiment of serenity. While the composition and iconography continue the Kushan-period formula, the soft, elegant modeling and rounded limbs are more characteristic of Gupta-period sculpture. The relief's small size may indicate that it was once intended for a domestic shrine.

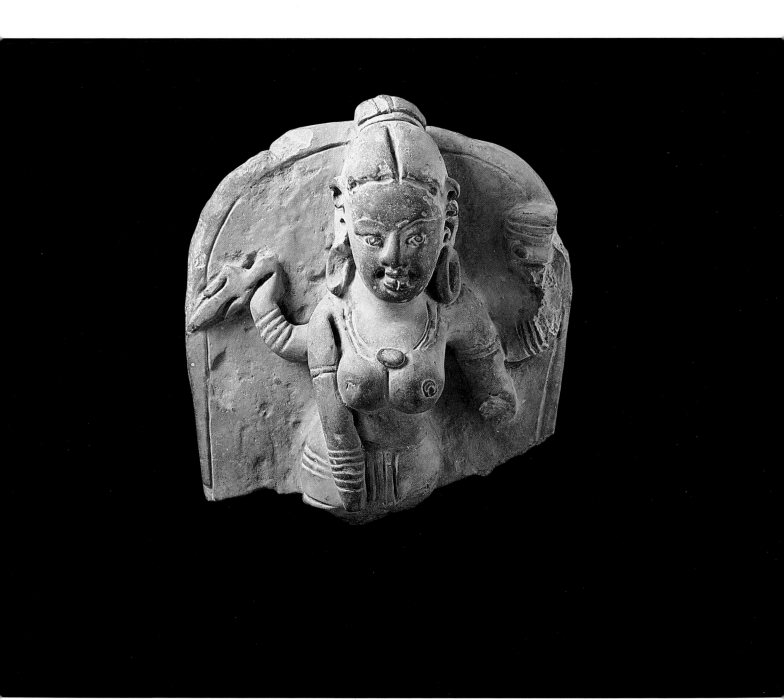

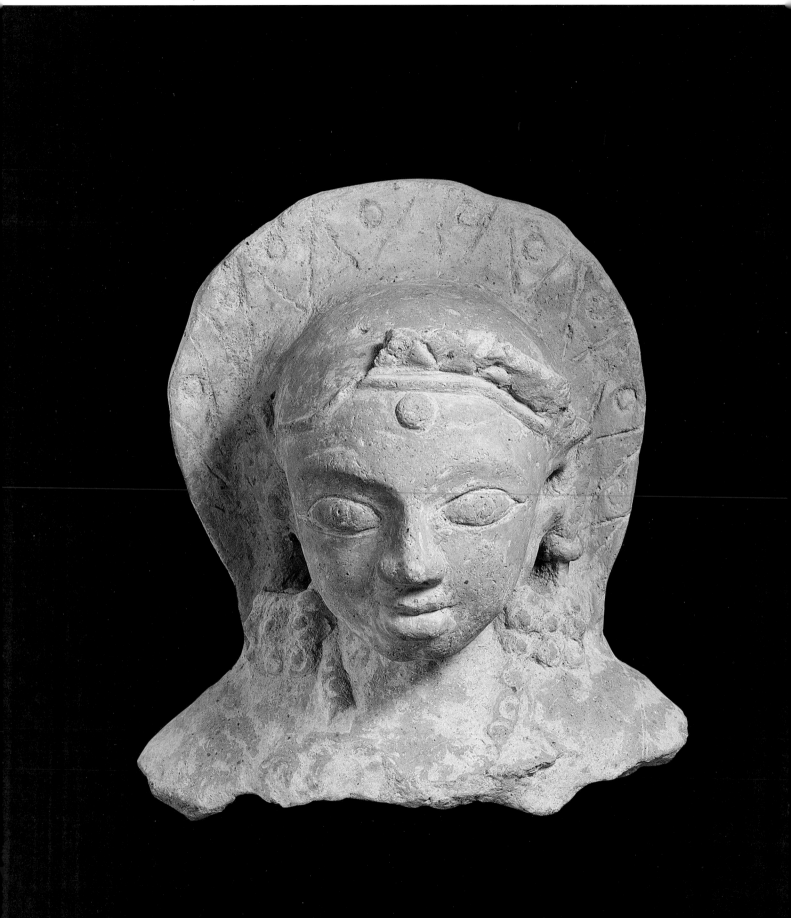

17   *Head of Goddess*
India, Uttar Pradesh; fifth century
Red terra-cotta; 13 1/2 in (34.2 cm)

This large head probably belonged to a life-size image of a goddess. When complete, the figure, if standing, would have looked as impressive as the two well-known images of the river goddesses recovered from Ahichchhatrā, Uttar Pradesh, capital of the ancient Panchala Kingdom (Harle 1974, pl. 139). Stylistically this head and those of the river goddesses are remarkably similar. Brick temples containing large terra-cotta images of mother goddesses were much more common during the Gupta period than surviving evidence indicates. The collection includes another slightly smaller head of the mother goddess Indrani from about the same period and region.

The exact identity of this goddess is not known. The large circle high on her forehead is considered to be a cosmetic sign of beauty and not of specific iconographic significance. The goddess wears substantial ear ornaments in the form of clusters of circles enclosing dots. The circular piece attached to the back of the head, adorned with a V-shaped dotted design, probably formed a headpiece but may also have served as a halo. It is remarkable that the face with its finely modeled features and serene expression is so well preserved while the rest of the figure is lost.

18   *The God Kubera*
India, Uttar Pradesh; fifth century
Reddish brown terra-cotta with traces of black and white pigment; 9 3/4 in (24.8 cm)

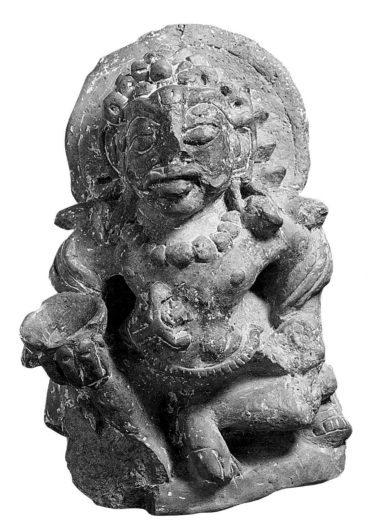

The slightly corpulent figure is seated in the graceful posture known as *lalitāsana*. Traces of white and black paint still adhere to the surface. The figure wears a dhoti and scarf across his shoulder. The dagger hilt on the right occupies much of his belly. His ornaments include a string of large pearls, ear ornaments, and what may be three skulls adorning the hairline. Ring-like curls cover his head, and he sports a stylish moustache above his rather thick lips. The third eye on the forehead and plain circular nimbus clearly announce his divinity. His right hand holds an empty bowl; his left hand is broken.

Despite the paucity of iconographic attributes, the figure can be identified as Kubera, god of wealth and guardian of the North. During the Gupta period he was often represented seated in this posture holding a cup in his right hand and moneybag in his left (Pal 1978, p. 104). The cup symbolizes his fondness for liquor, a characteristic of yakshas, a class of divinities much venerated in early India and even today in Indian villages. Among his many guises in Indian mythology, Kubera is lord of the yakshas. Less commonly represented, although not inappropriate, is the third eye. Kubera belongs to the Saiva family of deities and on occasion is considered to be a manifestation of Siva, who is often identified by the third eye.

*19    Symbol of the God Siva*
India, Uttar Pradesh; fifth century
Ocher terra-cotta; 3 3/4 in (9.5 cm)

This small, but well-proportioned Śivaliṅga was
probably intended for a domestic shrine. The
cylindrical symbol of Siva rises from a square
base and is embellished with a beautifully
modeled head of a youthful Siva, without,
however, his third eye (see Pal 1986, p. 240,
S116, for a stone head from Mathura without the
third eye). The square base is grooved to contain
the various liquids that are ceremoniously
poured over a linga; the drainage spout on the
side is broken.

It appears to have been a
common practice during the Gupta period to
model Śivaliṅgas in terra-cotta. Most, like this
example, seem to be well preserved, despite the
fact that they were regularly lustrated with
water, milk, and other substances. Very likely
these terra-cotta lingas were covered by metal
casings known as *kosha* and hence their
surprisingly uneffaced condition. For Siva's
devotees the linga is the most important symbol
of their lord.

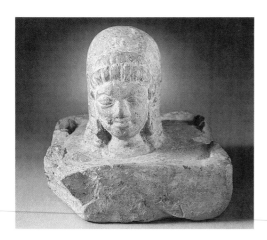
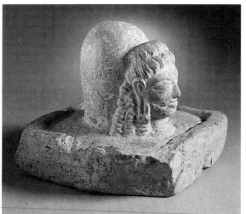

*20    The Divine Hero Rama*
India, Haryana, Nacharkherha (?); fifth century
Brown terra-cotta; 18 1/2 in (47.0 cm)
Gift of Marilyn Walter Grounds; M.83.221.6
Literature: Pal 1986, p. 232, S107.

A Brahmi inscription near the left thigh
identifies the figure as Rama, the deified hero of
the Sanskrit epic the *Ramayana*. An ancient king
who ruled Ayodhya (Ajodhya; now part of
Faizābād, Uttar Pradesh), Rama was considered
by the Gupta period to be an avatar of Vishnu.
This is probably the earliest inscribed
representation of the god found in India to date.
The fragment is stylistically related to other
inscribed reliefs found in the village of
Nacharkherha (see Literature). Obviously an

impressive Gupta-period brick temple
embellished with scenes from the *Ramayana*
must once have stood at the site. Some other
inscribed panels of the *Ramayana* (Poster 1986,
pp. 158–60, nos. 96–98) may also have
emerged from this little-known site.

Rama is attired as a heroic
warrior with a tunic and crossbelt (*channavīra*)
across his chest. Part of his famous bow remains
in the grasp of his left hand, while a quiver of
arrows is attached to his shoulders. Basically
Rama's image appears to have been modeled on
earlier representations of Kama, god of love.

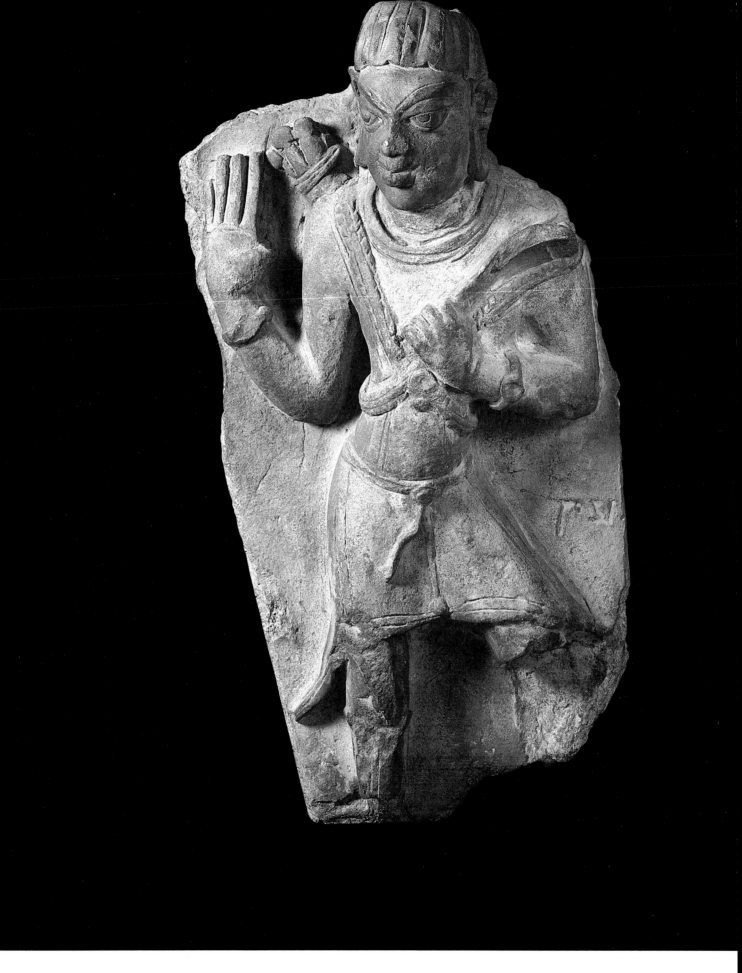

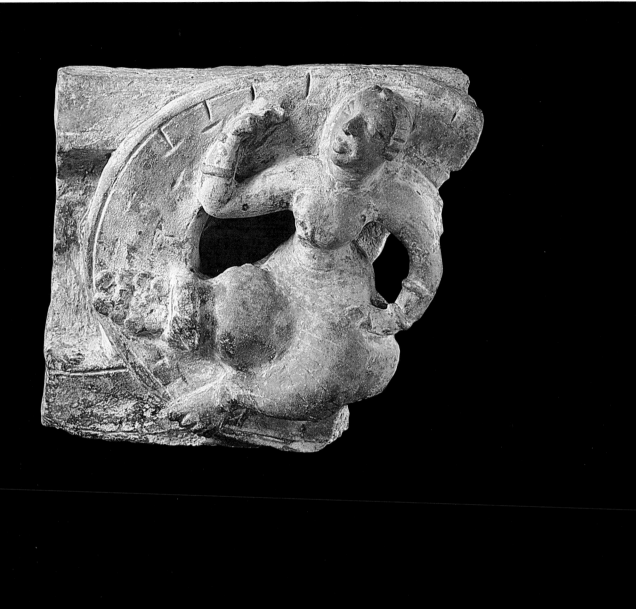

*21   Temple Panel with Goddess*
India, Uttar Pradesh, Ahichchhatrā (?);
fifth century
Reddish brown terra-cotta; 8 1/4 in (20.9 cm)

Originally used to embellish a Gupta-period
temple, this rectangular panel presents an
interesting composition. Although part of the
panel is broken, much of the well-formed,
sensuously modeled female figure is still intact.
Almost detached from the background, she
seems to look up as she sits astride what appears
to be a horizontally placed vase or jar disgorging
jewels. The jar itself is placed on the orb of a
broad circle, which frames the figure.

The exact identification of the
figure, which may be a unique representation, is
not known. A more complete example from
Ahichchhatrā (Agrawala 1947–48, p. 30, pl.
XLI) depicts seven females standing in a chariot
within such a circle. There seems no doubt that
the two panels are related and may belong to the
same temple and iconographical program.
Agrawala has identified the other panel as
representing the solar orb and the seven females
symbolizing sun rays. They may also represent
the Pleiades. In any event, a celestial association
for the female in this panel seems likely, and,
more precisely, she may be considered a divine
dispenser of wealth.

22    *The Planet Rahu (?)*
India, Uttar Pradesh; fifth century
Reddish brown terra-cotta; 6 3/4 in (17.1 cm)
Gift of Marilyn Walter Grounds; M.83.221.1
Literature: Pal 1986, p. 246, S123.

This articulately rendered and expressive demonic head may represent Rahu, who is regarded as the devourer of the sun and moon during an eclipse. Much feared in traditional India, he was worshiped along with Ketu, the personification of a comet, and the seven conventional planets. The large hands attached to the head would also indicate that this is Rahu, who is generally shown only as a bust. The plaque may have been part of a larger group of nine planets, a subject that began to be represented in temples during the Gupta period.

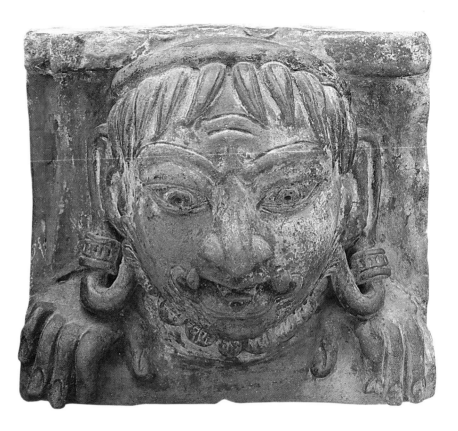

23    *Male Divinity*
India, Uttar Pradesh; fifth century
Red terra-cotta; 11 1/4 in (28.5 cm)

Like others in the collection (nos. 21–22, 24, 72), this fragmentary plaque once embellished a temple wall. While its exact identification is not known, the halo behind the head of this remarkably elegant, svelte figure indicates that a divine personage is represented. In his right hand he holds the lotus bud of dalliance (*līlākamala*), which may also indicate that he is a deified, mythical king.

Characteristic of Gupta-period figures, he wears a simple dhoti and single strand of pearls. Only the right ear is adorned with an ornament, and the hair is pulled back and coquettishly arranged in a bouffant at an angle behind the right ear. Once again, as with the paunchy male (no. 24), the plastic qualities are well executed, particularly the facial features and graceful fingers of the right hand, which are rendered with expressive clarity.

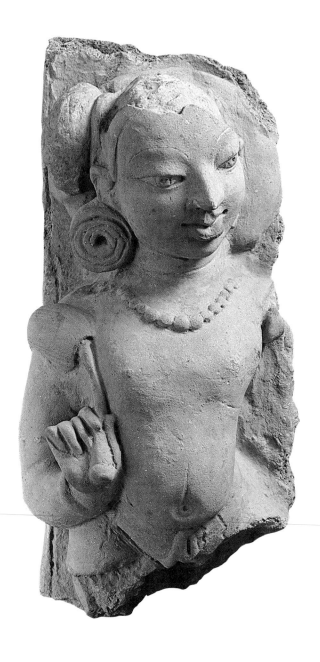

*24 Plaque with Male Figure*
India, Uttar Pradesh; fifth century
Red terra-cotta; 11 1/2 in (29.2 cm)
Literature: Dehejia 1986, p. 223, fig. 18.

The smoothly modeled figure stands elegantly and somewhat arrogantly with his left arm akimbo. He wears only a dhoti. A cord indicating his high caste is incised diagonally across his naked torso, which is dominated by an overhanging paunch. His hair is stylishly arranged in rows of plaits, and four ornamental disks with dots are attached at the temple. His exact identification is not known, but his swagger and generous girth leave little doubt that he is an important person. The presence of the sacred cord may indicate that he is a prosperous brahmin or divine ascetic. The three rings around his neck, imitating the swirls at the mouth of a conch, make the representation that of an idealized figure. Otherwise the form is naturalistically modeled with articulately rendered folds of flesh along the outline of the torso. Both this and the nimbated figure (no. 23) may have belonged to a temple that once stood at Kopa in the Basti District, Uttar Pradesh (see Kala 1980, frontispiece; Poster 1986, pp. 166–67, nos. 104–5, for other stylistically related narrative panels).

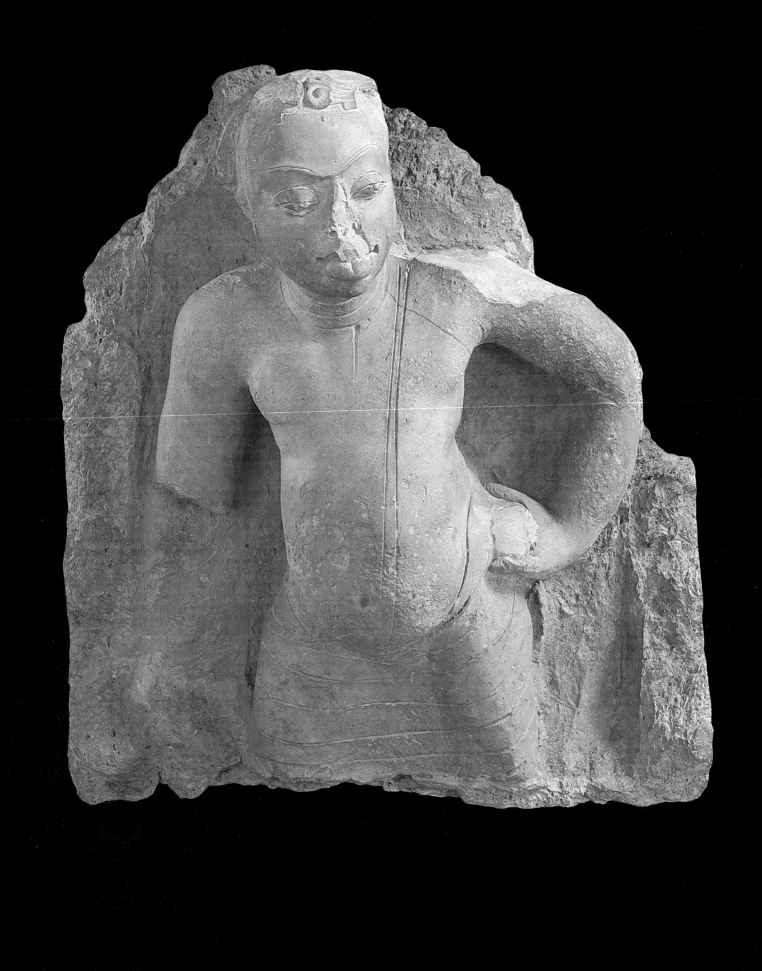

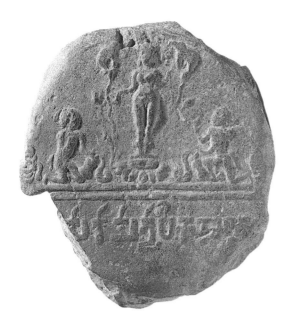

25    *Seal Impression with Gajalakshmī*
India, Bihar, Basarh; fifth century
Ocher terra-cotta; 3 1/4 in (8.3 cm)

This oval seal impression is of a well-known type of which three specimens were excavated from Basarh (Bloch 1903–4, pls. XL–XLI). The village of Basarh is the site of the ancient city of Vaiśālī, an important administrative center of the Gupta Empire. The inscription, in square Brahmi characters of the Gupta period, states that the seal belonged to the office of a minister or district officer, who was also a junior member of the royal family (*kumāramātyādhikaraṇa*).

The goddess adorning the seal is Gajalakshmī, or Lakshmi, goddess of fortune, being bathed by elephants. On either side of her lotus base kneel two well-proportioned males who appear to extract money from bags. The motif is particularly appropriate for the seal of the principal administrative officer of the district. In contrast to the hieratic posture of the goddess, the two male attendants are represented naturalistically as are the elephants. The goddess is a slim and elegant figure, comparable in modeling and proportion with female images on the reverse of Gupta gold coins.

26    *The God Ganesa*
India, Uttar Pradesh (?);
seventh–eighth century
Red terra-cotta with traces of red pigment;
8 3/4 in (22.2 cm)

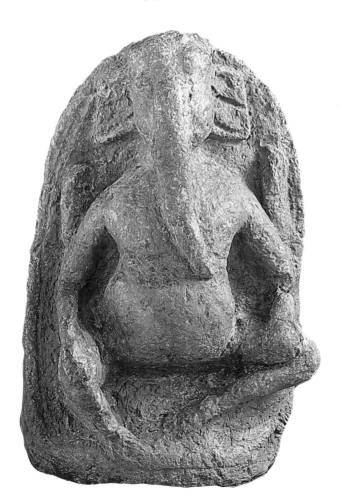

Ganesa is the elephant-headed god of auspiciousness, who is universally adored in India and other Asian countries influenced by Indian religious ideas. He is usually represented as a potbellied figure, a legacy of his yaksha past. In Hindu mythology he is the son of Siva and Parvati, and his obesity is said to have been caused by his inordinate love for sweets. In what remains of his lower-left hand he holds a ball of sweets. Ganesa's other attributes usually are a rosary, symbolizing asceticism; a battle-ax for removing obstacles; and one of his own broken tusks, perhaps signifying plenitude. (For other explanations and theories about the concept of Ganesa, see Courtright 1985.)

Not only was this terra-cotta image once painted a bright red, but traces of ritual unguents still adhere to the surface. The overall effaced condition of the image is due to the constant application of such unguents during worship. Although somewhat coarsely fashioned with stumpy upper arms, the figure is quite attractive because of its informal posture and lively naïveté.

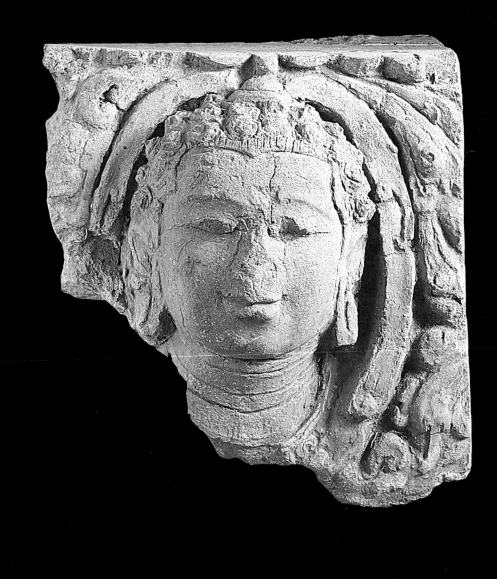

27    *Head of the Buddha*
Indonesia, Central Java; c. eighth century
Terra-cotta; 9 in (22.9 cm)
Published: Pal 1984, p. 212, no. 96.

This enclosed head of the Buddha is a rare early terra-cotta sculpture from Central Java. It is said to have been recovered from the ruins of a brick temple in the Dieng Plateau in Central Java. Existing temples in that area date from the eighth century and are made of stone. One cannot, however, dismiss the early existence of brick temples in Java, considering the popularity of the material in India and mainland Southeast Asia at this time. Terra-cotta panels and images certainly graced many of the brick temples in Thailand during the Dvāravatī period.

Although the nose is broken, the features are well modeled. Characteristic of Buddha images, the earlobes are extended unnaturalistically and the head is covered with rather large, conelike curls. The cranial bump (*ushṇīsha*), by contrast, is somewhat inconspicuous. Unusual also is the bandlike strip with vertical striations separating the temple and hairline. The three auspicious lines are clearly marked around the neck, and the eyes are half shut, making the expression serene and contemplative. A simple ring serves as the halo for the recessed head, and the remaining portion of the panel is adorned with vegetal designs (see Thomsen 1980, p. 98, no. 92). Very likely the panel was placed in a niche on the external wall of a temple as in contemporary Thai monuments.

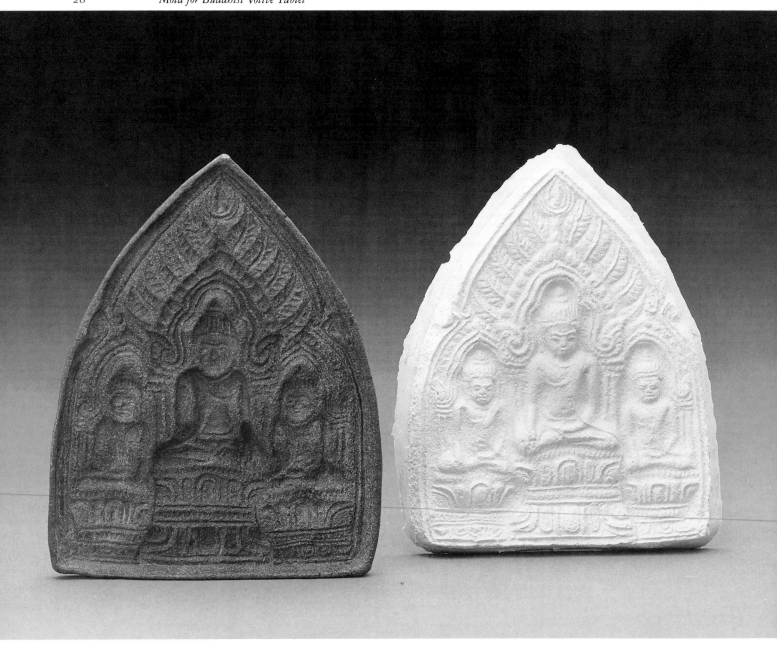

28     *Mold for Buddhist Votive Tablet*
Thailand; eighth—ninth century
Bronze; 4 1/2 in (11.4 cm)

Because of the great demand for votive tablets, they were manufactured in large quantities from molds made of both terra-cotta (see also no. 30) and bronze. Bronze molds would probably have had a longer life than those made of terra-cotta, and, therefore, surviving impressions from such molds may have been produced long after the date of the mold itself. Several such molds belonging to the Dvāravatī period (sixth–eleventh century) have been found in various sites in Thailand.

This particular example is well preserved and has a handle at the back with which the mold was pressed into clay. In front are three identical meditating Buddhas, who sit on lotuses beneath arches. Each displays the gesture of touching the earth with his right hand. Above the central arch are leaves of the bodhi tree, recalling the Buddha's enlightenment at Bodhgaya. Made much later than the other two figures, the central Buddha no doubt represents Sakyamuni.

That the mold belongs to the Dvāravatī period is certain, but neither its exact date nor provenance can be ascertained. Iconographically more elaborate tablets of a similar shape and configuration have been recovered from the ruins of Wat P'ra Men in Nakhon Pathom Province (Dupont 1959, pl. 17, nos. 46–47). This particular mold is probably earlier than those tablets.

29    *Buddhist Votive Tablet*
Thailand; ninth century
Red terra-cotta; 7 in (17.7 cm)
Gift of Marilyn Walter Grounds; M.85.284.5

In the center of this votive plaque is the enthroned figure of a meditating Buddha. His left hand rests on his leg, and his right hand, held across his chest, displays his open palm with the index finger and thumb of each hand touching. His head is surrounded by a halo that seems to be fringed with stylized flames. Above the halo is a parasol symbolizing his spiritual sovereignty. Two flywhisks and two poles surmounted by wheels flank him. Six diademed figures, the bottom two with halos, sit on either side and adore him.

The most unusual iconographical features of this plaque are the gesture of the Buddha's right hand and the addition of the wheels and flywhisks. The gesture is very likely a variation of the wisdom gesture (*jñānamudrā*) and is rarely encountered in Buddha images either in Thailand or elsewhere. The royal flywhisk, one of the eight auspicious Buddhist symbols, is usually held by a bodhisattva, and only in votive plaques of the Dvāravatī period in Thailand are they placed by themselves in this manner (Dupont 1959, figs. 34–38, 41–45). The Wat P'ra Men tablets also include the wheels. The wheel is one of the most important symbols of Buddhism and signifies the faith itself. A special cult of the wheel with further symbolic ramifications seems to have flourished in Thailand (Brown 1985). The diademed and nimbated figures may represent gods, in which case the Buddha may be engaged in preaching in Indra's heaven.

Scholars of Thai art consider such tablets to show Indian influences, but their iconographic peculiarities exhibit local theological developments. An almost identical tablet, probably from the same mold, was found in a Dvāravatī-period stupa near the ruins of the ancient city of Muang Bon in the Byuhagiri District, Nakhon Svarga Province (Yupho [1965], fig. 87).

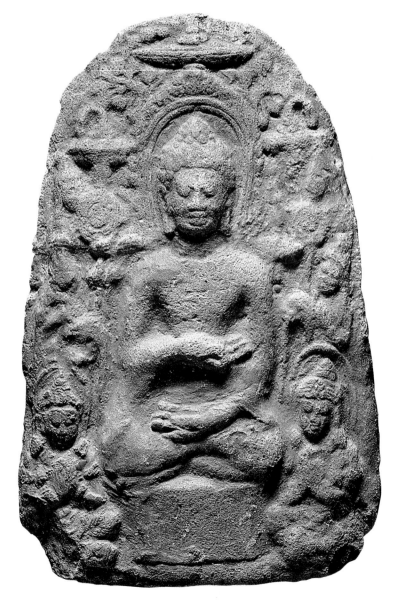

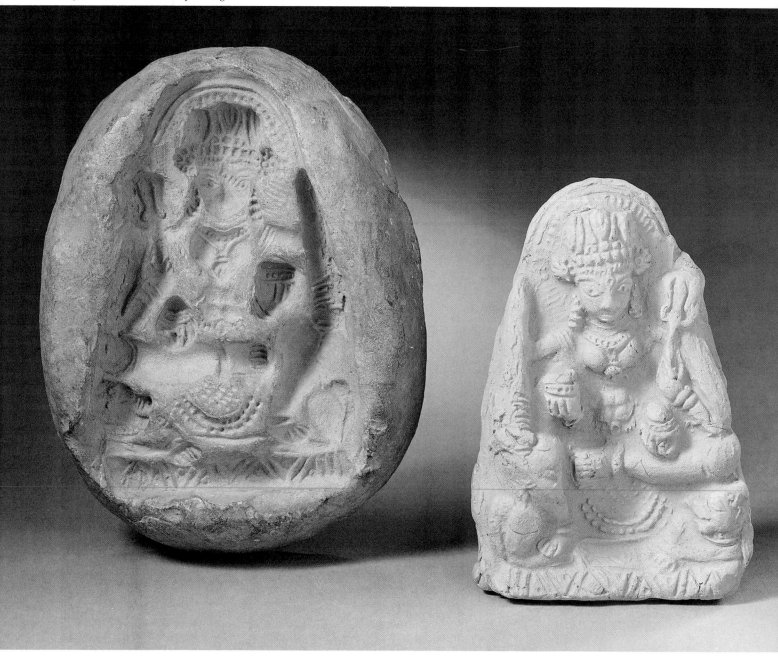

30    *Mold for Image*
India, Kashmir; eleventh century
Buff terra-cotta; 7 1/4 in (18.4 cm)

This is a typical example of a terra-cotta mold probably used repeatedly to meet the large demands for effigies of especially sacred and potent images. The goddess represented is Durga, who is seated on her lion mount in *lalitāsana*. The only attribute that can be clearly recognized is the trident, held against the shoulder by one of her left hands. Crowned and bejeweled, the goddess also displays the third eye, clearly marked on the forehead. Except for her mouth, almost all her features and details of jewelry are sharply delineated. (For several other such molds discovered in various parts of India, see Poster 1986, pp. 193–97.)

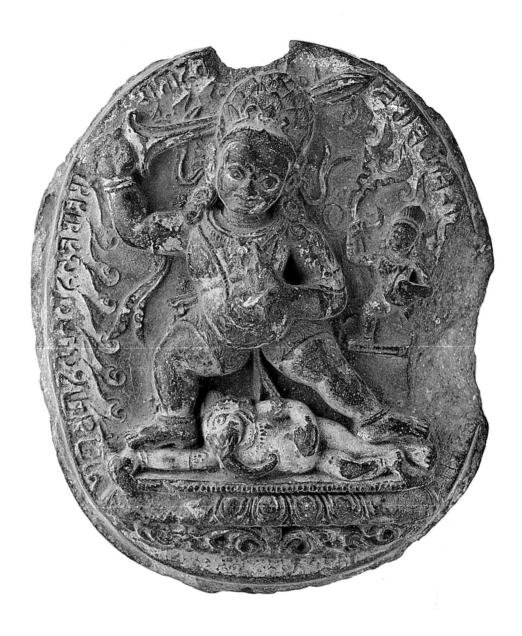

*31     Buddhist Votive Tablet*
India, Bihar (?); eleventh century
Ocher terra-cotta with black, red, and white
pigment; 3 3/4 in (9.5 cm)

This is one of the finest Indian terra-cotta
plaques of the period. Much of its original pig-
ment survives, giving us an idea of the appear-
ance of such plaques at the time of their manu-
facture. It was found inside a Tibetan metal
image, which is why it is so well preserved.

  The larger of the two figures
represents the Vajrayana Buddhist deity Vigh-
nāntaka (destroyer of obstacles). Brandishing
two swords and displaying the gesture of
admonition, he holds a noose with his left hand
and tramples Ganesa, who is stretched out on a
lotus base. Appropriately the god is black and
potbellied, with an awesome face and menacing
posture. His terrifying nature is further
emphasized by the striking red flames forming
an aureole behind him. A smaller version of the

god, holding what looks like a scythe, is repre-
sented on his left. Ganesa's body is painted
white, but his trunk is red. This image obvious-
ly displays the sectarian bias of the Buddhists, as
Ganesa is regarded by the Hindus as the remover
of all obstacles (see no. 26). Along the edge of
the plaque is inscribed the Buddhist creed
beginning with the words *ye dharmā*.

  In addition to its polychromy,
the plaque is also interesting for its bold
modeling and exquisite detailing. Although the
plaque is said to have emerged from Tibet, very
likely it was taken into that country by a Tibetan
pilgrim soon after its manufacture in Bihar. Both
the style and Nagari inscription indicate its
Indian origin, although Indian images were so
faithfully copied in Tibet during the eleventh
and twelfth centuries that sometimes they are
difficult to distinguish.

32    *Buddhist Votive Tablet*
Burma, Pagan (?); twelfth century
Pinkish red terra-cotta; 4 in (10.1 cm)

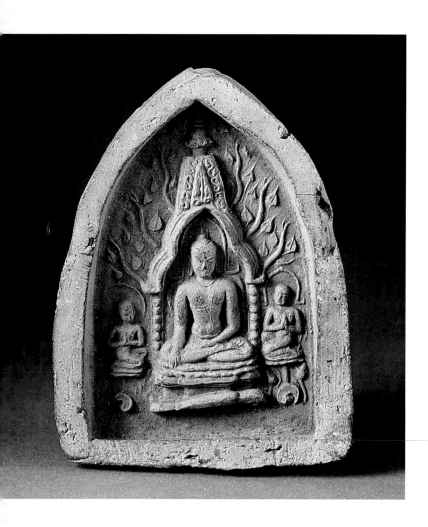

This well-preserved votive plaque is almost identical to several others found from various sites, including the temple city of Pagan, the capital of Burma during the twelfth century (Luce 1969–70, pl. 58). There seems no doubt that all the examples were made from the same mold, probably at Pagan, and carried away by pilgrims to various places. The representation is recessed inside the arched tablet, which is why it is better preserved than the shallower tablets.

The subject represented is Buddha Sakyamuni seated within a shrine with a tall spire. With his right hand Sakyamuni forms the earth-touching gesture, symbolizing his enlightenment. This interpretation is further confirmed by the leafy branches of the bodhi tree that spread out like rays around the shrine. The two kneeling monks on either side portray the adoring Sāriputra and Mudgalyāyana, the two principal disciples of the Buddha. On the reverse is an engraved inscription in Pali: *Namobuddhāya* (Honor to the Buddha).

The almost pristine condition of the tablet and fact that it is not painted probably suggest that the piece may have been inserted into a stupa or some other structure. Several such tablets have been recovered from sacred edifices.

33    *Buddhist Votive Tablet*
Burma; twelfth century
Dark brown terra-cotta with black and red pigment; 6 1/2 in (16.5 cm)

An almost identical tablet of the same size and height with rim was found in Taungdwingyi; smaller and rimless examples have also been discovered in Pagan and Bodhgaya (Luce 1969–70, pls. 32–33). Most have the Buddhist creed written in Nagari script along the bottom, only faint traces of which remain on this example. Whether the molds were made in Bodhgaya and taken to Burma or the examples discovered in Bodhgaya were left there by Burmese pilgrims cannot be determined. The figurative style in most such tablets is extraordinarily similar to the contemporary sculptural style of Bihar.

The principal iconographic difference between this and the first tablet (no. 32) is the exclusion in this example of the two disciples and addition of six stupas. The central enshrined image is the Buddha Sakyamuni within the temple at Bodhgaya. Unfortunately the face of the Buddha is disfigured. This, together with the fact that it was once brightly painted — traces of red and black pigment still remain — and has a broad base indicate that it must have been used in a private shrine. The thick, square base would also support such a conclusion.

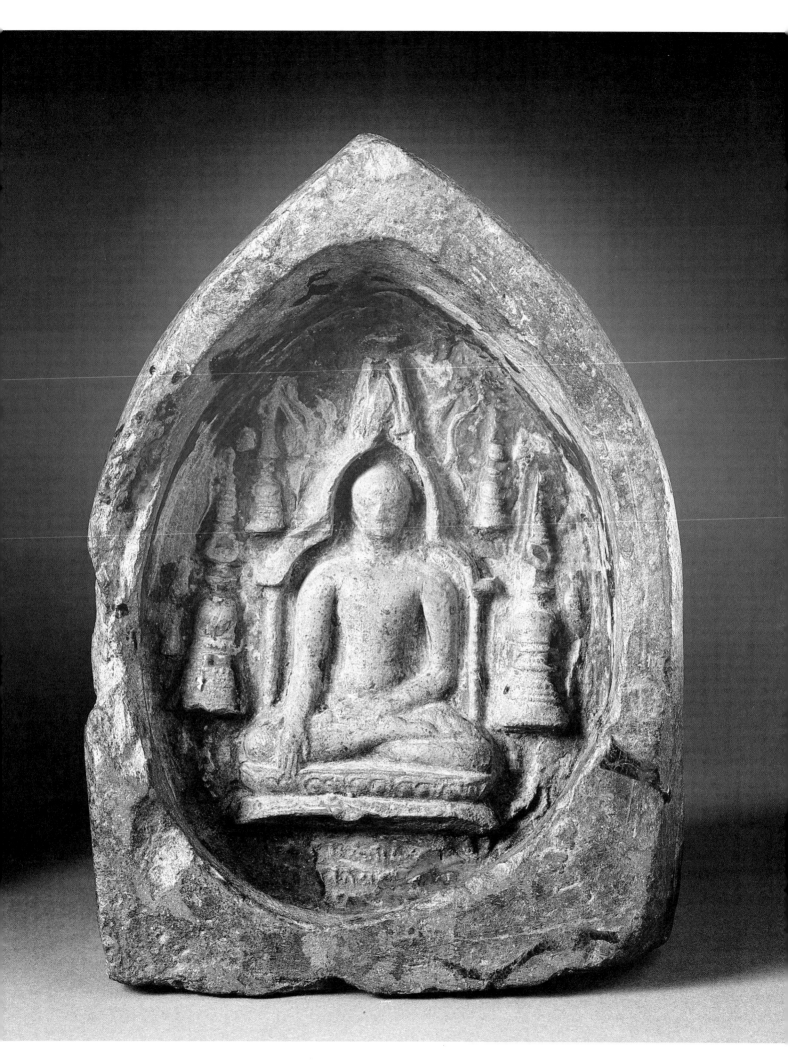

**34    *The Buddha Sakyamuni***
Burma; twelfth–thirteenth century
Terra-cotta with beige slip; 5 1/2 in (13.9 cm)

This miniature representation of Buddha Sakyamuni probably served the same function as the votive tablets made for private use. It is, however, conceived as a sculpture, like a small bronze, rather than a tablet.

A crowned and ornamented Sakyamuni is seated on a lotus above a high pedestal. The slab behind him is pointed at the top. His outstretched right hand displays the earth-touching gesture symbolizing his enlightenment at Bodhgaya, where images of the adorned Buddha were popular during the Pāla period (c. 750–1200). Ornaments and crown are usually given to the celestial manifestation of the Buddha in Vajrayana Buddhism.

Stylistically the image is closely related to tenth–eleventh-century Buddha figures from Bihar. While the cult of the crowned and adorned Buddha inspired an abundance of standing figures, mostly in wood, in thirteenth-century Burma, few seated figures in terra-cotta or bronze are known. Thus, although not as well preserved as the tablets, this small image is of considerable historical interest.

**35    *The Buddha Sakyamuni***
Thailand, Lamphun Province (?);
thirteenth century
Brown terra-cotta; 21 1/2 in (54.6 cm)
Literature: Dehejia 1986, p. 223, fig. 20.

When complete this Buddha figure must have been of impressive proportions. It was made to decorate a niche on the external wall of a temple, as are those that still adorn the stepped, pyramidal stupa of Wat Kukut in Lamphun Province (Boisselier and Beurdeley 1975, p. 146, fig. 105). From the seventh century until its overthrow in 1292, the ancient kingdom of Haripunchai was centered in the Lamphun region. During the twelfth and thirteenth centuries the artists of Haripunchai created a very distinctive figurative type with unique facial features, as seen in this Buddha figure and a small crowned head (no. 36) in the collection.

Although the simple and abstract modeling of the figures continues the earlier Dvāravatī style, the Haripunchai figures have wider and squarer shoulders and powerfully modeled torsos. Their heavy thighs and rather straight legs create a solid, columnar effect. This terra-cotta sculpture was made in two halves, and the thighs do not appear to be clearly defined. The shape and features of the faces distinguish these figures. Broad and square, the typical face has a strong well-defined chin, heavy lips with the suggestion of a moustache, prominent nose, and partially shut large eyes with bulging pupils. The hair is rendered in pointed knobs with a rather high, conical cranial bump and clearly demarcated hairline above the broad temple. These features, combined with their gentle facial expressions, make these Buddhas among the most original and aesthetically appealing of all Thai sculptures.

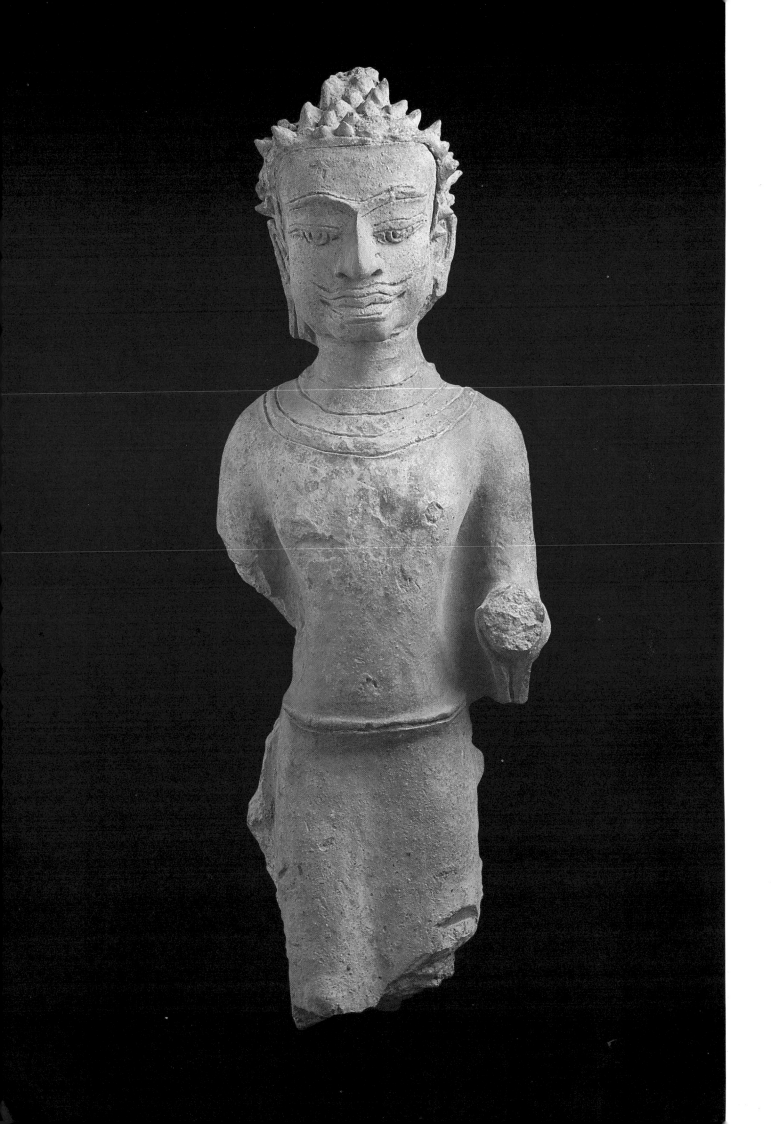

*36   Head of Deity*
Thailand, Lamphun Province (?);
thirteenth century
Reddish brown terra-cotta; 6 3/4 in (17.1 cm)

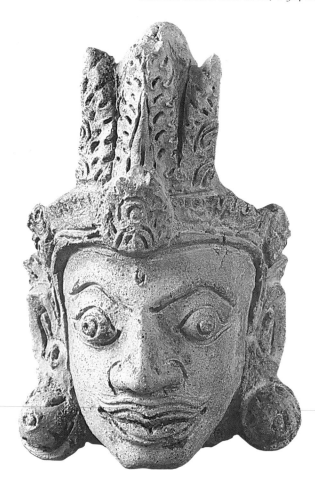

A large number of such crowned heads in the typical Haripunchai style of the thirteenth century have been found in Lamphun Province. Writing about another similar head, Jean-Michel Beurdeley stated: "Nothing is known of the figure of which only this head remains; possibly it was a worshiper or a royal personage from an illustration of one of the *jataka* stories. The lively, expressive features are somewhat overemphasized, and are faintly suggestive of the Dvaravati tradition" (Boisselier and Beurdeley 1975, pp. 232–33).

    The shape and features of the face as well as the design of the diadems of such heads are indeed remarkably varied. This particular head, with its long, oval face, is especially well preserved. Characteristic of the Haripunchai school are the prominently bulging eyeballs and circle incised in the middle of the forehead, representing the auspicious tuft of hair (*urṇā*). The eyebrows are more sharply curved than in other examples, and the diadem is adorned with a rich vegetal motif. Despite their idealization the heads are individualized and may represent deified royal portraits. Because of the presence of the *urṇā*, however, an identification with a bodhisattva cannot be dismissed.

*37   Temple*
Indonesia, East Java;
thirteenth–fourteenth century
Reddish-brown terra-cotta; 50 1/2 in (128.3 cm)

This is the largest and most complete example of such terra-cotta temples known from Java (for another complete, although much smaller example see Muller 1978, p. 70, pl. 125). Their exact function, however, is not known. As the openings into the sanctum are very small, they could not have been used as shrines. They may have had a votive purpose or been used as subsidiary shrines at the corners of terraces supporting larger temples. Since the temple is hollow and the upper section can be detached, it is possible that it was used as a funerary shrine in which to deposit the remains of the dead (see Bernet Kempers 1959, pl. 207, for similar structures used as tombs). In any event, it faithfully reproduces to the minutest detail the type of temple typical of East Java.

    The temple has two stories, although there are no staircases for access to either level. The main lower story has four openings in the cardinal sides. The entrances are framed by columns and crowned by grinning monster faces known in Java as *kāla,* or time. The most conspicuous symbolic element of Javanese architecture, the *kāla* has an Indian prototype known as the *kīrttimukha,* or face of glory. An auspicious emblem, the *kāla* is also frequently employed over entrances to ward off evil. The upper story has only one entrance in the front. The pyramidal shape of the temple is appropriate to its symbolic significance. All Hindu and Buddhist temples are microcosmic representations of the cosmic Mount Meru, the axis mundi connecting heaven and earth.

    Stylistically the temple relates to stone examples still standing in Biltar, although it is less ornate than most. While the best-known Biltar temple, Chandi Panataran, is dated 1369, others were built in the thirteenth century (Bernet Kempers 1959, pls. 214–15).

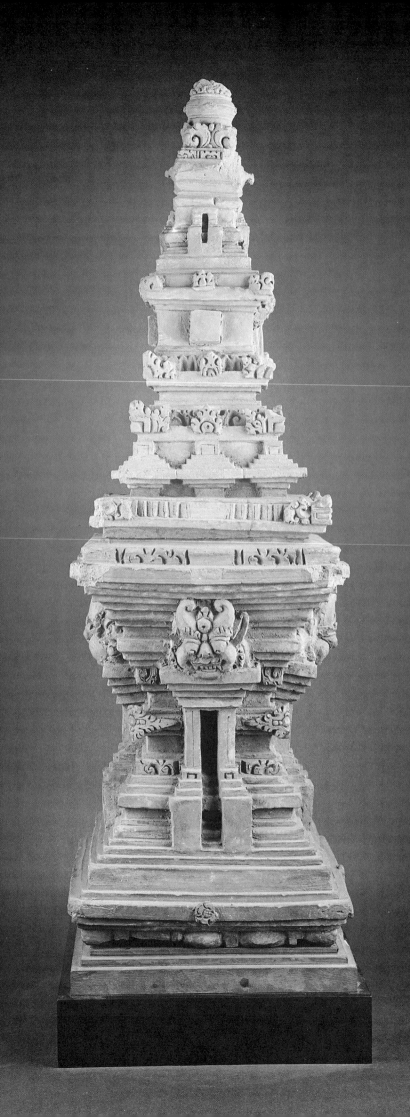

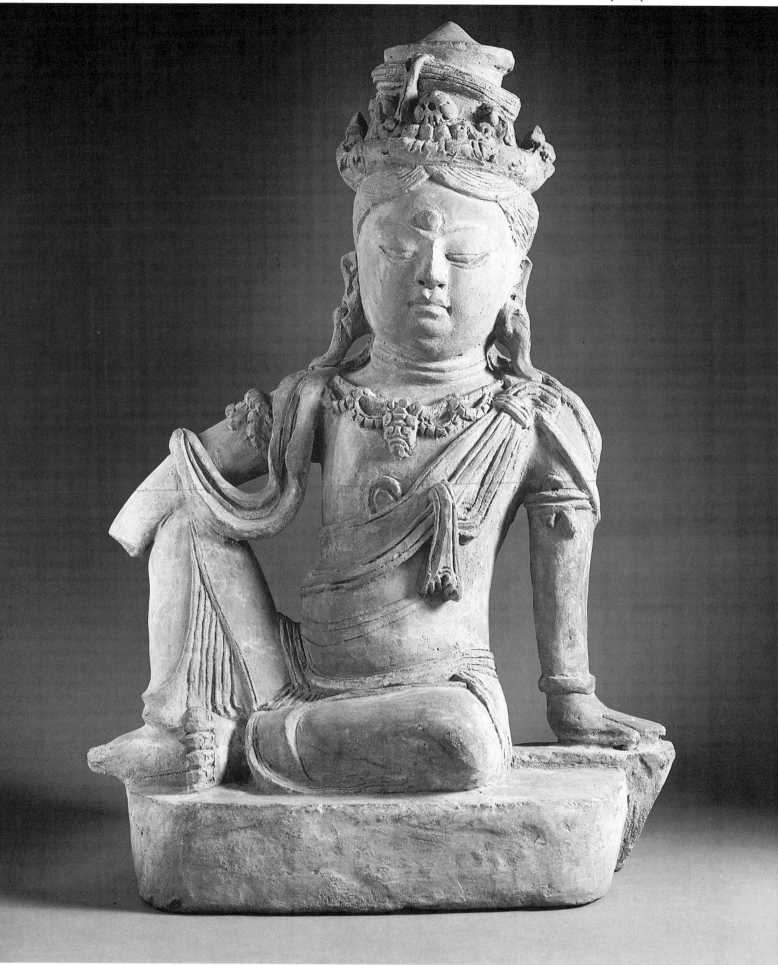

**38** *The Bodhisattva Avalokiteshvara*
Indonesia, East Java; fourteenth century
Buff terra-cotta; 21 in (53.3 cm)

This is unquestionably one of the most important Buddhist sculptures in terra-cotta to have been found in Java. Not only is it the largest Buddhist figure in terra-cotta discovered to date in Java, but it represents a type of bodhisattva image popular in China. Indeed, no other Javanese sculpture is as strongly influenced by Chinese Buddhist imagery as is this example.

One of the finest Chinese images of this type is the polychromed wood bodhisattva from the eleventh–twelfth century in the Nelson-Atkins Museum of Art, Kansas City, Missouri (*Handbook Nelson Gallery of Art Atkins Museum*, 1973, 2: 39–40). Either this very image or another, more sacred, example must have served as the prototype for the Javanese figure. Very likely a model, in bronze or ceramic, was brought to Java by a visiting Chinese pilgrim. Stylistically the terra-cotta bodhisattva is more akin to Yuan period (1279–1368) sculptures, such as that in the Metropolitan Museum of Art, New York, dated to 1282, or another in the Nelson Gallery (ibid., p. 41).

Bodhisattva Avalokiteshvara, an embodiment of compassion, is the most important of the Mahayana Buddhist deities. This particular image type, in which the bodhisattva is seated in the graceful posture of royal ease (*mahārājalīlā*), usually on a rocky base, is said to express the form assumed by the deity in his mythical abode in Mount Poṭalaka on an island near southern India.

While Buddhism continued to flourish in East Java during the Singhasari period (1222–92), contacts with China were strong in the fourteenth century. The stylistic relationship with Yuan-period sculptures also suggests a fourteenth-century date for this remarkably well-preserved image.

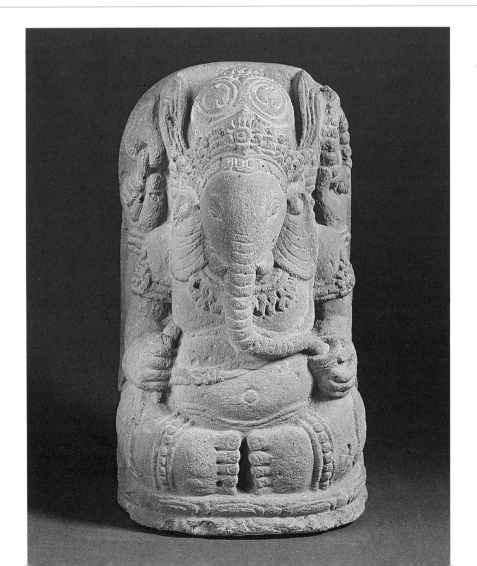

### 39 The God Ganesa

Indonesia, East Java; fourteenth century
Ocher terra-cotta; 11 in (27.9 cm)
Gift of Marilyn Walter Grounds; M.83.221.3

The Hindu god Ganesa is seated on a lotus with his legs forming a circle below his ample belly (see also no. 26). This awkward posture appears to have been a hallmark of most Javanese Ganesa figures, but it makes him no less endearing. Elaborately crowned and ornamented, he has four arms that hold various attributes. The upper-right hand grasps a battle-ax, the lower-right a part of his tusk, the upper-left a rosary, and the lower-left a bowl of sweets. He is busy eating the sweets with his trunk.

Stylistically this terra-cotta Ganesa is simpler than most stone examples of the period from East Java. The closest parallel is offered by the Singhasari Ganesa of about 1300 (Bernet Kempers 1959, pl. 235), where the figure is also set off against an aureole. Moreover, the Singhasari Ganesa holds the battle-ax and the rosary with his upper hands, as does this figure. The sculptor responsible for this terra-cotta image seems to have misunderstood the form of the battle-ax, especially in the way the blade is attached to the handle, making it appear almost like a fan. Such well-preserved terra-cotta representations of Ganesa from Java are especially rare (Muller 1978, p. 40, pl. 75).

### 40 Goddess

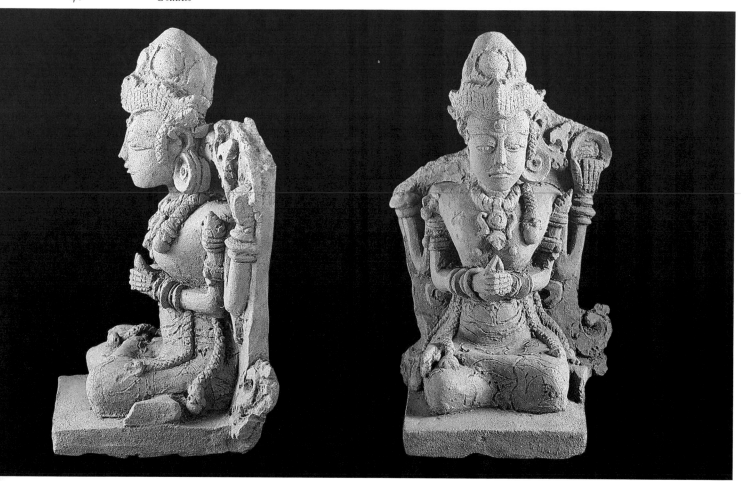

### 40 Goddess

Indonesia, East Java;
fourteenth–fifteenth century
Red terra-cotta; 9 3/4 in (24.7 cm)

Crowned and bejeweled, the four-armed goddess is seated on a plain base in the meditating posture known as the heroic posture (*vīrāsana*). Her upper-right hand is broken; her corresponding left hand holds a rosary. Rather unusual is the gesture she forms with her other pair of hands below her breasts. Known as the "gesture of the inner bonds," it is formed by joining the two palms and interlocking the fingers. Seen more often in Buddhist art, the gesture represents release from the bondage of the passions (Saunders 1985, p. 119).

Since many of the gestures are common to both Hindu and Buddhist deities and rituals, it is difficult to determine the exact identity of this goddess. In the Hindu context she may represent Parvati, wife of Siva, and in the Buddhist context, Prajnaparamita, goddess of wisdom. Whatever her exact identification, such terra-cotta images of cosmic deities are not frequently encountered in Java.

41   *Woman under Tree*
Nepal; fourteenth–fifteenth century
Red terra-cotta; 12 1/8 in (30.7 cm)

An elegant lady stands below a mango tree. Part of the background behind her is delineated as a rocky terrain. In front of her a stream runs down from a crop of rocks. A dead dog with its stomach split open lies beneath the tree. His entrails dangle from the beak of a bird resting halfway up the tree. Two more birds are perched on the leafy branches above, one holding a human leg in its beak, the other eating bits of entrails. The lady seems to have stopped in her tracks upon encountering the dead dog. She points at it with her right hand as she raises her left hand in the gesture of reassurance. The scene is reminiscent of the formulaic representations of cremation grounds in tantric paintings. Here too the locale may well depict a cremation ground, and the female may portray one of the stereotyped group of eighty-four *mahāsiddhas* venerated by Buddhists (Pal 1985, pp. 122–23, S48, for another terra-cotta representation of a *mahāsiddha*). Among the eighty-four, three were female, and one of them, Maṇibhadrā, had to visit a cremation ground to be initiated by her guru Kukkuripā (Robinson 1979, p. 208–10).

Whatever the exact identification of the scene, this is one of the finest terracotta sculptures to have survived from Nepal. The idealized female figure, with her smooth, rounded, full form, is an embodiment of sensuous grace. Although the rocks are rendered as jagged cubical shapes and the clusters of mangoes appear to defy the laws of gravity, the skillful manipulation of the various forms and figures makes the composition visually attractive and technically sophisticated. That the unknown sculptor was completely confident with the material is evident from the unusually bold modeling of the forms, which seem almost independent of the relief to create a convincing illusion of space.

Detail

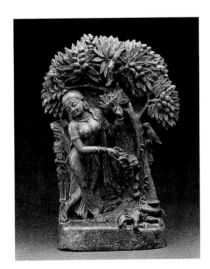

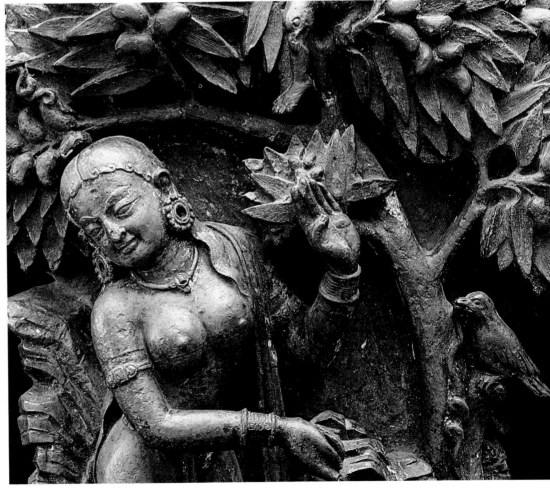

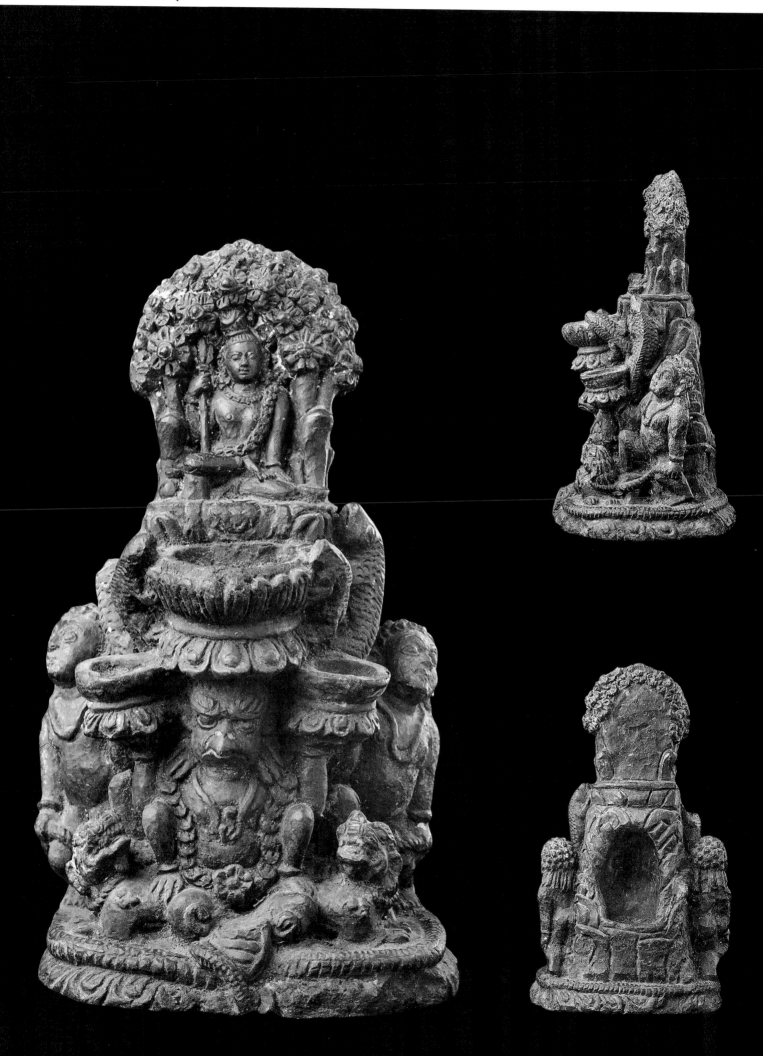

## 42 Lamp
Nepal; fifteenth century or earlier
Reddish brown terra-cotta with traces of
vermilion pigment; 13 in (33.0 cm)

This elaborate and unique terra-cotta lamp is
a rich composition of various forms. Seen from
the back, it is clearly conceived as a mountain
rising from a lotus base. At the summit a yogi or
god is seated under the canopy of a flowering
tree. The figure's elegantly matted hair is
adorned with a crescent. In addition to his
various ornaments he wears a garland, or floral
band, across his left shoulder. In his right hand
he holds a trident. A jar and bowl are placed on
either side of his legs, which are disposed in a
yogic posture. Immediately below him are three
lotus-shaped lamps of varying sizes. Two small
alligators or crocodiles scale the sides of the large
lamp, while two larger members of the same
species climb the sides of the summit. The lamps
are supported by a garuda trampling two lions
who are restrained by leashes attached to their
backs and held by two cherubic figures. They
look like Siva's dwarfish attendants known as
ganas. Each supports a smaller lamp with one
hand. A snake encircles the upper edge of the
lotus base. On the back the rising rocky
formation is interrupted at about the middle by a
cavelike niche that may once have contained
another image.

The exact identification of the
figure at the summit is difficult to determine.
He may be Siva, but he has no third eye. He may
be the Buddhist Simhanāda or the
Harihariharivāhana form of Lokeśvara.
Simhanāda is usually depicted like Siva with a
trident and seated on a lion. Harihariharivāhana
usually sits on Vishnu, who is supported by
Garuda, who rides a lion, or the figure may well
be a celebrated yogi such as Gorakhnāth or
Matsyendranāth, both of whom are much
venerated in Nepal. Whatever the figure's exact
identity, the inclusion of the climbing reptiles
and cherubic figures holding the lions like pet
dogs is highly unusual. Although not as refined,
the subject is stylistically akin to another equally
fascinating sculpture in the collection (no. 41).
The two cherubs are remarkably similar to an
earlier wood figure of a standing dwarf in the
museum's collection (Pal 1985, p. 93, S11).

## 43 Head of the God Bhairava
Nepal; late fifteenth century
Red terra-cotta; 19 1/4 in (48.9 cm)

A large pot, parts of which still remain, was once
attached to the back of this impressive Bhairava
head. The pot was filled with beer, which was
dispensed from a pipe inserted in the mouth and
eagerly drunk by the devotee as consecrated
beverage. Although this ceremony takes place
during the annual festival of the Vedic god Indra,
the head represents Bhairava, the angry
emanation of the Hindu god Siva.

The broad, bearded face, with
fangs protruding from the open mouth, is
dominated by three large discoid eyes that
enhance the ominous character of the visage. The
eyes symbolize the sun, moon, and fire and
impart a cosmic significance to the form. The
tiara consists of a row of skulls signifying
Bhairava's triumph over death and time. The
center of the tiara is adorned with a peaceful head
of a bodhisattva, very likely the Buddhist
Mañjuśrī, bodhisattva of wisdom. On either side
of the head are four rearing serpent heads. Thus
the iconography of these heads seems to derive
from the Buddhist rather than Hindu tradition,
but Bhairava is adored universally.

Although the pot behind the
head is broken, the face is preserved almost
flawlessly. Characteristic of Nepali
representations of Bhairava, the expressive,
masklike face is awesome with its bulging eyes,
fanged mouth, and skull tiara (Alsop 1986,
cover, p. 24, fig. 14). Nevertheless, these
remarkably well-modeled Bhairava heads are
among the most engaging examples of Nepali
sculpture. The head was made considerably
earlier than a more flamboyant bronze example
dated to 1560, whose present location is not
known (Alsop 1986, p. 24, fig. 14). For a more
complete example, photographed during an
Indra festival, see Slusser 1982, 2: pl. 362.

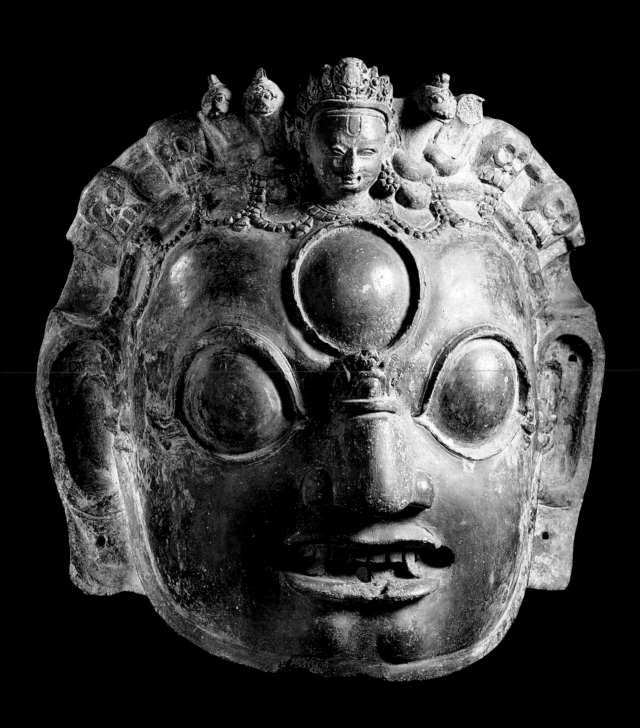

44   *Head of the God Bhairava*
Nepal; seventeenth century
Reddish brown terra-cotta; 11 3/4 in (29.8 cm)

Although not as large as the earlier example (no. 43), this masklike Bhairava head served the same function. A comparison of the two heads clearly reveals the inventiveness of the Nepali artists in repeatedly giving shape to the same iconographic form. While the larger head sports only a beard and the hair is not visible, here the artist has made the visage even more dramatic by adding a stylized moustache, beard, florid eyebrows, and thick strands of hair that rise like a crown of dancing flames or serpents.

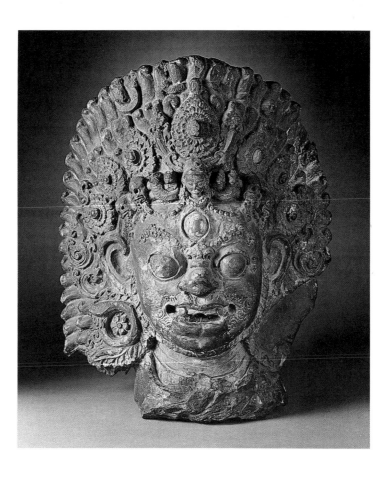

45   *The Divine Regent Vaiśravaṇa*
Nepal; seventeenth century
Brown terra-cotta; 6 7/8 in (17.4 cm)

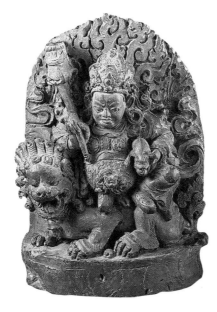

Attired in a coat of mail and boots and elaborately crowned, Vaiśravaṇa, divine regent of the North and god of riches (see also no. 18), is seated on a roaring lion. In his right hand he holds a parasol, and in his left hand a mongoose disgorging gems. The aureole behind him is enlivened with a stylized flame motif and swirling scarf. The details in this crisply modeled, animated sculpture are rendered with precision and finesse.

This form of the god originated in Central Asia and remained popular in Tibet and East Asia. Vaiśravaṇa was regarded as a defender of the faith, and his bearing is appropriately martial. Not only does he display a scowling expression, but his lion is a menacing creature. The parasol symbolizes his cosmic sovereignty. Why the mongoose became associated with riches is not entirely clear. Perhaps purses were once made from the animal's skin.

46   *Cosmic Form of the Bodhisattva Lokeśvara*
Tibet; seventeenth century
Terra-cotta with gold and orange pigment;
12 in (30.4 cm)

The central figure with eleven heads and one thousand arms represents the cosmic form of Bodhisattva Lokeśvara, or Avalokiteshvara, the most important deity of later forms of Buddhism. This particular manifestation is especially popular in Tibet, where the Dalai Lama is considered to be his emanation. The eleven heads of the bodhisattva probably represent the ten directions and the center, while the thousand arms symbolize the cosmic powers of the god as well as the universe (Pal 1982). Of the eight principal arms, one pair displays the gesture of greeting, while the other six (beginning with the lower right and clockwise) exhibit the gesture of charity and hold the flaming wheel, rosary, lotus, bow and arrow, and pot of elixir. Each hand in the second pair forms the gesture of charity with one palm marked with an eye. Lokeśvara is flanked by the seated figures of Mañjuśrī on his right and the angry form of Bodhisattva Vajrapāṇi on his left.

As was the custom among Tibetans, the figures have golden complexions and the background is a deep orange. The hair of the tenth head is also painted orange, in keeping with his ferocious visage. The arched frame is decorated with a lively floral scroll painted a coppery brown. This shade is also used for the additional arms, except the eight principal arms, garments, and lotuses. The image probably graced a small shrine either in a home or monastery.

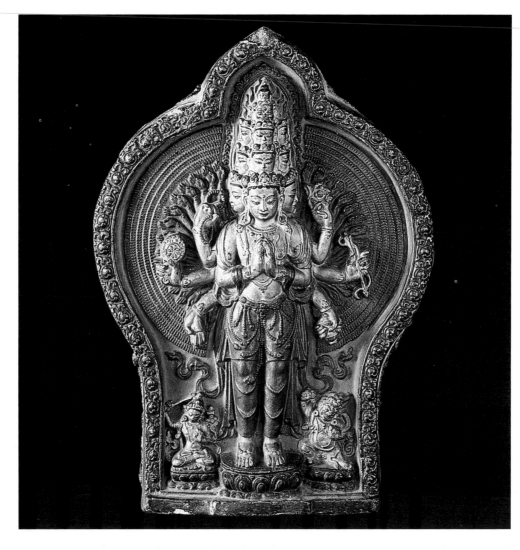

47   *Plaque with Buddhist Deities*
Tibet; eighteenth century
Terra-cotta with red pigment;
11 1/2 in (29.2 cm)
Gift of Marilyn Walter Grounds; M.84.220.2

This plaque is a rare example of a terra-cotta mandala (a geometrical configuration with images used in tantric rituals and meditation). In the center is the figure of Amitāyus, the Buddha of immortality, seated on a lotus with his consort in his lap. He is surrounded by the five transcendental Buddhas, each holding his attributes and embracing his consort. At the summit, symbolizing the zenith, is the Adi Buddha, or the primordial Buddha, embracing his consort, Prajnaparamita, who embodies the fivefold transcendent wisdom. Three guardian deities are represented immediately below Amitāyus, and along the bottom are three dancing goddesses. Eight stupas and vajras (thunderbolts) form the perimeter of the mandala; solar and lunar symbols flank the Adi Buddha. Cloud formations above and two trees below Amitāyus place the figures in a rudimentary landscape. Four syllables in Tibetan script representing the *vījamantra* (seed incantation) are added below and above the two trees.

The transcendental Buddhas are shown in their celestial bodies and are, therefore, crowned and ornamented. Such mandalas were used in special esoteric rites following such early and arcane texts as the *Gūhyasamājatantra* (tantra of secret society). The addition of the guardian figure on the right, emerging from a triangular dagger and holding an arrow, indicates that the shrine was probably used by a Nyingmapa. An ancient sect in Tibet, the Nyingmapas are particularly prone to esoteric religious practices.

Much of the surface of this plaque is blackened by smoke, but along the sides the original red paint still adheres. The figures were probably once painted gold as in the other plaque (no. 46). (For more elaborate versions contained in wood shrines see Pal 1969, pp. 117–18, and Zwalf 1985, pp. 141, 143, no. 200.)

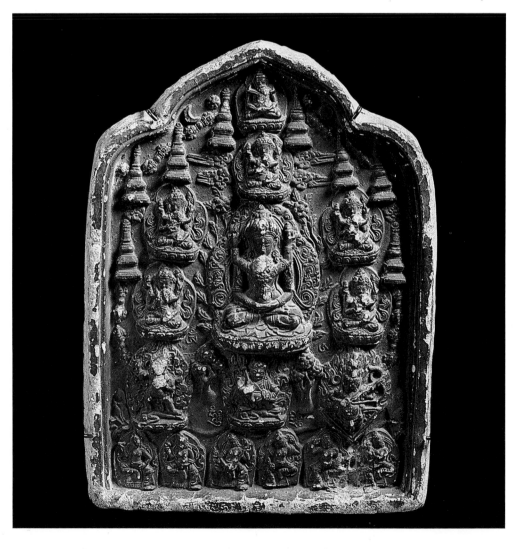

# Images of Whimsy  Animals and Composite Creatures

48    *Forepart of Animal*
India, Uttar Pradesh, Mathura;
third century B.C.
Gray-black terra-cotta; 8 in (20.3 cm)

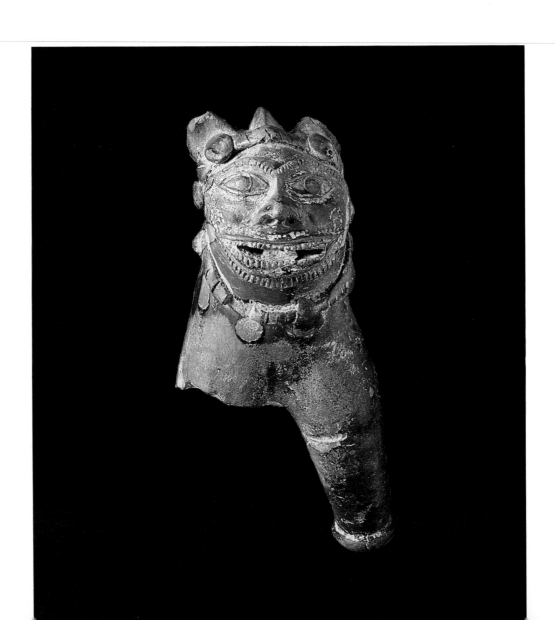

Notwithstanding its damaged condition, this is an unusual and expressive example of a Maurya-period terra-cotta animal sculpture. The representation is so stylized and whimsical that it is almost impossible to identify the animal precisely. If it is meant to be a lion, then the absence of a mane would indicate that it is a female rather than a male member of the species. Or, the collar around the neck and forehead may demonstrate its domesticated nature, and the animal could, therefore, be a dog. Nevertheless, what is interesting is the almost human expression conveyed by the shape of the nose and large almond-shaped eyes.

*49    Elephant*
India, Uttar Pradesh, Mathura;
third century B.C.
Black terra-cotta; 5 1/4 in (13.3 cm)

Although part of the trunk and one tusk are missing, this is an attractive Maurya-period representation. The artist's self-confidence is evident in the manner in which he has combined naturalism with abstraction. The head and trunk are rendered realistically, and the body and legs are modeled with great economy and simplicity. Rows of circles are added as decoration, and two long cloth strips hang over the ears. The eyes are diamond shaped with dotted pupils.

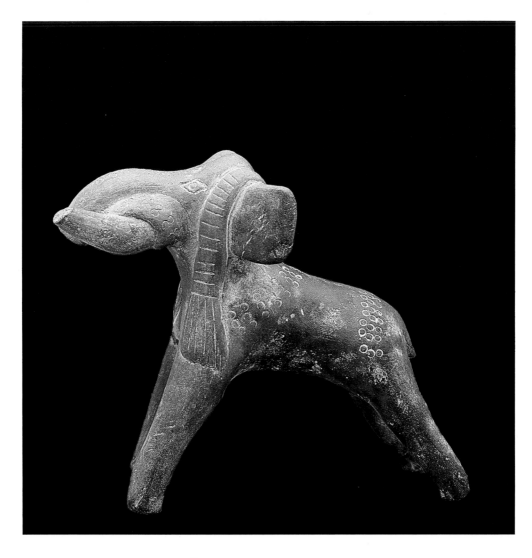

50   *Toy Elephant*
Pakistan; c. 100 B.C.
Red terra-cotta; 5 in (12.7 cm)

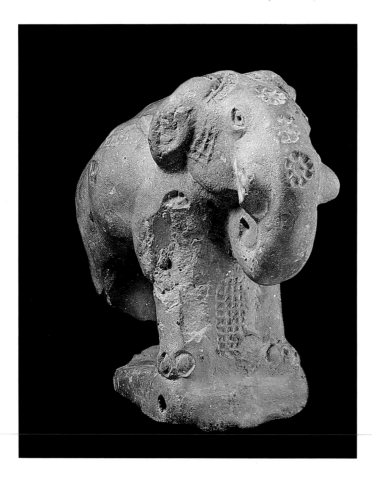

In contrast to the contemporary horse from the same region (no. 54) and elephant from Mathura (no. 49), this animal is a very naturalistic representation. Like the horse, it too was obviously used as a toy as is clear from the holes at the front of the base and through the curled trunk. At least five elephants "with holed legs obviously for the attachment of wheels" were found in Shaikhan Dheri (Dani 1965–66, pp. 88–89). Incised on the animal are the frills of a carpet on the back, ornaments around the neck and head, and banner in front. As has also been found on other toy elephants from Taxila in ancient Gandhara, the trunk and upper legs are stamped with lotuses (Marshall 1951 [1975], pl. 134, nos. 72, 75, 77–78; no. 77 is a caparisoned elephant like this example). Whether the stamped decorations were symbolically significant or purely decorative is not known. The decorations appear to have been characteristic of elephants produced only in Gandhara.

51   *Miniature Chariot*
India, Uttar Pradesh, Kausambi;
first century B.C.
Red terra-cotta; 5 1/2 in (14.0 cm)

This is probably one of the finest surviving examples of a type of chariot known in the classical world as a biga. Whether such chariots were designed originally in India or copied from European models after Alexander's visit in the fourth century B.C. is not known. The latter alternative, however, seems more likely. This well-preserved model is of great cultural significance as it represents a three-dimensional type of chariot frequently depicted in stone reliefs of the period. A second example is in the Patna Museum (Lee 1964, no. 21), while a part and a mold for a front section of two others are in the Allahabad Museum. All were recovered from Kausambi, which is very likely the source for the present example (Kala 1980, figs. 209, 325).

The front of the chariot is embellished with a pair of harnessed bulls richly adorned with garlands. The remaining space is filled with lotuses. Lotuses also are strewn on the chariot's platform, and the wheels are lotiform

as well. On the outside the two walls are decorated with a combat between a charging lion and a warrior equipped with a spear and shield. Each is a spirited composition, naturalistically depicting a combat, and interestingly the position of the combatants differs on the two sides. By contrast, the bulls in front, with their tall, bamboolike legs, appear to have been rendered in a more stylized fashion.

It is generally assumed that these miniature chariots represent toys, but they may also have had religious significance. The flowers on the platform may symbolize the sacredness of the object, for it is an ancient tradition in India to strew flowers at a site to indicate divine presence. Moreover, several terracottas discovered in West Bengal show gods riding on chariots drawn by rams, bulls, or horses (Biswas 1981, figs. XIa–b, XIII–XIVa). Thus, it is possible that this chariot once contained an image of a deity and was used during a festival. In Orissa and Bengal children still pull model chariots bearing images of Jagannatha of Puri on the day of the god's festival in August; the festival is called Rathayatra, the chariot festival.

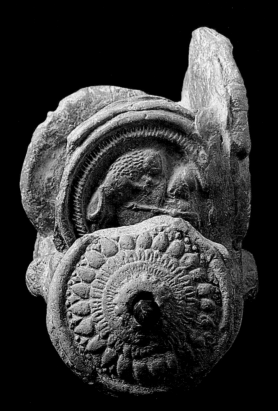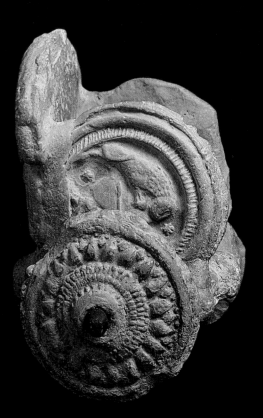

*52    Toy with Demonic Creature*
India, West Bengal, Chandraketugarh;
first century B.C.
Reddish brown terra-cotta; 5 5/8 in (14.3 cm)

This is a typical example of the kind of toys with which children in ancient India loved to play. Such toys have been found in various urban centers across northern India. One of the richest sites was Chandraketugarh in West Bengal. Situated on a river some thirty miles northeast of Calcutta, Chandraketugarh appears to have been a bustling port from about the second century through the end of the Gupta period in the seventh century. Terra-cotta seems to have been the principal artistic medium for the citizens of this city.

This particular example shows a demonic creature seated on a hollow barrel. An axle with wheels would have been inserted through the barrel, and a child would have pushed the mobile toy with a stick inserted in the hole at the middle of the back. Such creatures are known in Indian literature as yakshas, and they played an important role in the popular religion of the time. Even now in village India they are used as bogeys by mothers to control their children. With its wide, almost leering grin and furrowed brow, this example is especially expressive and well crafted. Because it represents a yaksha, the toy may have been used in religious festivals (see also no. 51).

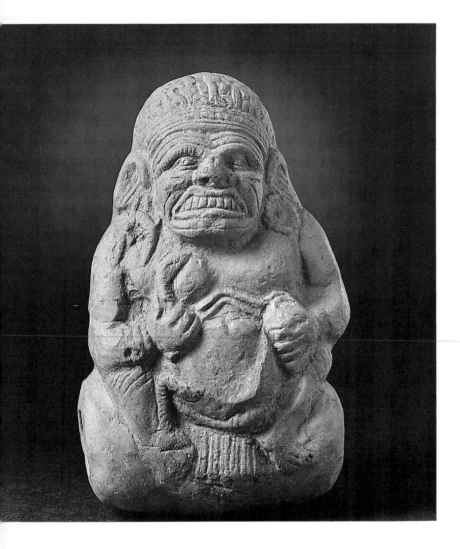

*53    Toy Ram*
India, West Bengal, Chandraketugarh;
first century B.C.
Reddish brown terra-cotta; 6 1/4 in (15.9 cm)
Gift of Marilyn Walter Grounds; M.84.220.8
Literature: Pal 1986, p. 146, S26.

Toy carts in the shape of the forepart of a ram appear to have been quite popular in several urban sites across northern India during the Śuṅga (187–75 B.C.) and Kushan periods. Whether in fact rams were used to draw children's conveyances is not known, but certainly in Gandharan reliefs of the Kushan period, the young Buddha is often depicted riding to school on a ram or in a cart drawn by rams.

This particular example is very likely from Chandraketugarh, a site that continues to yield terra-cotta sculptures of great variety and interest (Pal 1986, pp. 124, 141–43, 145–46). The realistic representation of the head, especially the surviving horn, clearly indicates the local sculptor's familiarity with this animal. As with the more elaborate toy chariot (no. 51), an axle, inserted through the barrel-shaped chest of the ram, would have been attached to two wheels, and the toy would have been pushed from the back with a stick.

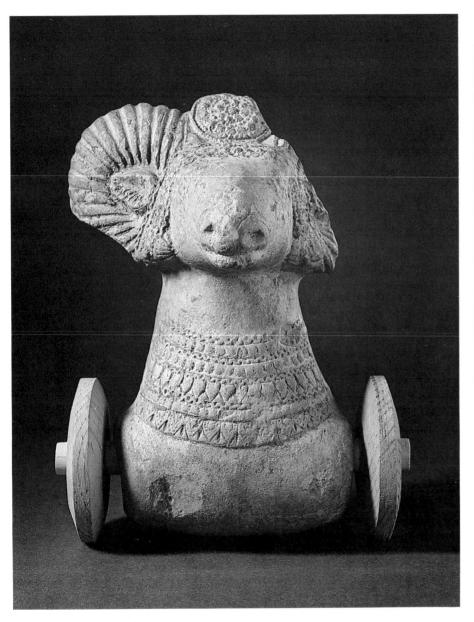

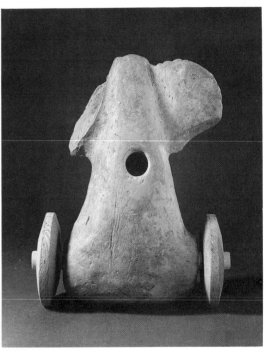

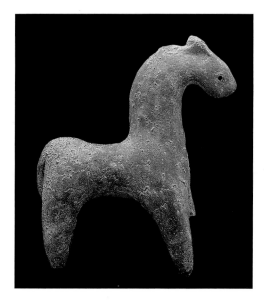

54     *Toy Horse*
Pakistan; first century B.C.—first century A.D.
Red terra-cotta; 4 3/4 in (12.0 cm)

The hole across the horse's rather thin face indicates that the animal was perhaps pulled with strings. The abstract modeling is reminiscent of the many similar terra-cotta animal toys found in Taxila (Marshal 1951 [1975], pls. 134–35). A large number of horses, some of which are saddled, were also excavated from Shaikhan Dheri (Dani 1965–66, pl. XXXVIb–c, pp. 85–88). Most representations of the horse published by Marshall and Dani are fragmentary, while this example is almost complete.

     Despite its folk character, the animal displays a classical style. The horse has a long, graceful neck, strongly modeled rump, and extended, flat underside, reminiscent of Etruscan models. Several horses discovered at Shaikhan Dheri have similar long necks, and the closest comparison is offered by the best-preserved example (Dani 1965–66, pl. XXXVIb, no. 5). This particular piece was recovered from the early Kushan stratum (first century), but it should be noted that horses have been found in all strata dating between the midsecond century B.C. and midsecond century A.D.

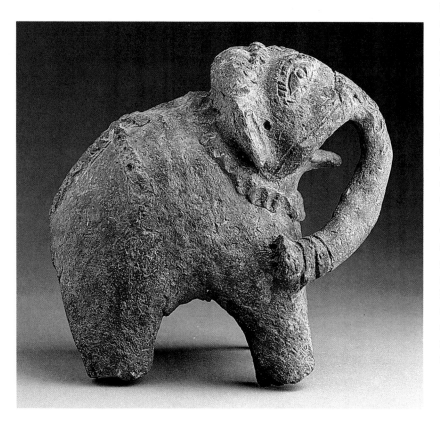

55     *Elephant*
Sri Lanka; first century B.C.—first century A.D.
Reddish brown terra-cotta; 8 in (20.3 cm)

Since early times the elephant has been a favorite motif in the art of Sri Lanka, and the island is one of the principal habitats of the animal. Sri Lankan artists were particularly adept at rendering stone elephant reliefs with both empathy and naturalism. The animal was also frequently represented on terra-cotta tiles, but freestanding representations such as this example are rare. Moreover, when working in terra-cotta, artists seem to have preferred a more whimsical depiction, with little concern for anatomical detail. Nonetheless, this example is informed with both individuality and lightheartedness.

     The hollow elephant has a wide-open mouth, and its trunk sways to the right. Although the large fish-shaped eyes are unnatural for the elephant, they aptly express the artist's whimsy. A pendant hangs on the fore-head, and a collar and crossbelts adorn the curved back. The proboscis is prominently indicated, and the bulky body and heavy legs are less naturalistically modeled. The applied tail and tusks have broken off, and the legs are damaged.

*56   Three Monkey Musicians*
India, Uttar Pradesh; second century
Reddish brown terra-cotta;
5 x 8 in (12.7 x 20.3 cm)

Such votive objects have been found at several Kushan sites across northern India. The closest morphological and stylistic analogies for this piece are offered by a large group of fragmentary examples found at Ahichchhatrā (Agrawala 1947–48, pp. 125–26). Stylistically similar and equally lively representations of monkeys have been discovered in large numbers, although not in groups, at Shaikhan Dheri (Dani 1965–66, pl. XXXVIII) from the Kushan levels. None of the Ahichchhatrā examples, however, is as well preserved as this specimen, nor do the other figures represent monkeys as they do here.

In a turreted, walled enclosure are seated three monkeys, each with a distinctly different face, playing three different instruments. The figure in the middle with a lyre is flanked by two drummers. Each wears a wide torque, and a bowl is placed in front of each (street musicians all over India today still collect money in such bowls from passersby). The front ends of the wall are embellished with tree and snake motifs.

The exact function of these curious objects is not clear. Agrawala has suggested that they may represent votive tanks or model shrines. The bowls in front of the animals may have been meant as receptacles for offerings, donations, or alms. Considering the popularity in India of the monkey-god cult, such objects may have held some kind of votive significance. Music is an essential part of Hindu worship, and such terra-cotta orchestras may have been offered to temples as mute, but permanent substitutes for live performers. The presence of simian rather than human musicians, however, adds a droll touch.

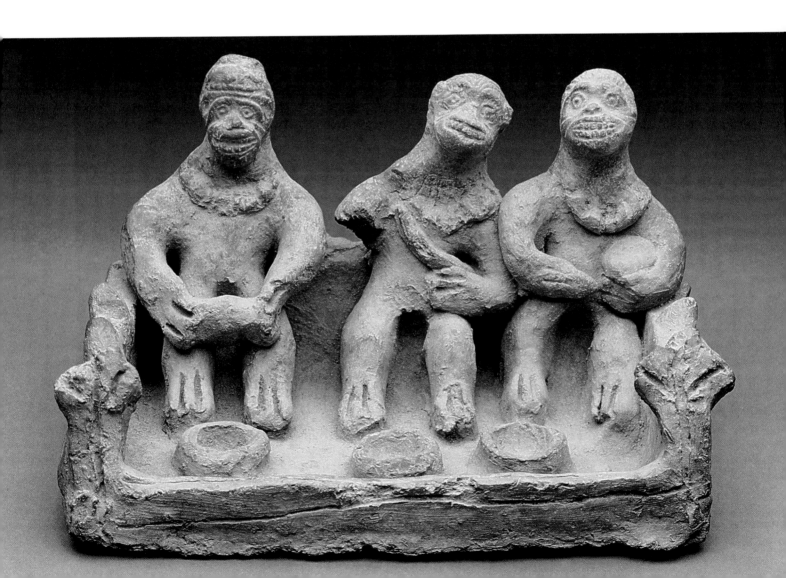

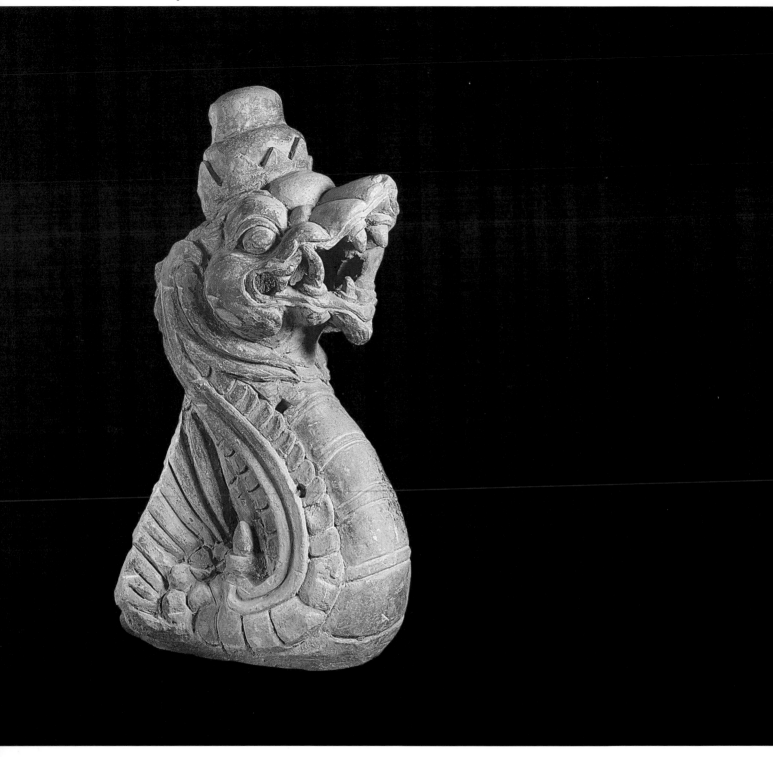

57    *Composite Creature*
Indonesia, East Java; thirteenth century
Light brown terra-cotta with traces of pigment;
21 in (53.3 cm)

This imaginatively designed form is a composite of three different species. While the body is a serpent, the head is leonine, and the two short appendages may represent wings or fins. The creature carries above its head what looks like a jewel on a lotus, suggesting that the composite creature depicts a serpent, or naga. In Indian mythology serpents are believed to be hoarders of jewels, which are either disgorged by them or carried on their hoods as crowning elements.

This impressive object, like the ceramic piece from Thailand (no. 65), may have served as either a roof finial or endpiece for a balustrade. Or, it may have supported the spout of a Śivaliṅga, as may be seen in a fine stone example found in the neighborhood of Prambanan in Central Java (Bernet Kempers 1959, pl. 166). There too the rearing serpent is open mouthed and supports a lotus on its head. Another stone naga with a jewel on its head recovered from the Dieng Plateau is said to date from the twelfth to thirteenth centuries (Thomsen 1980, pp. 112–13). (For two other fragmentary examples see Muller 1978, p. 80, pls. 149–50.)

### 58   Bowl with Bird
Indonesia, East Java; thirteenth century
Ocher terra-cotta; 8 in (20.3 cm)

Few objects demonstrate the East Javanese artists' inventive flair and assured mastery of material as well as this extraordinary object. Very likely it is a shallow bowl with a relatively tall, flaring neck or it may have served as a covering for a wood or bamboo column (see no. 82). The form of the bird projects considerably from the body of the bowl and is given its own fully rounded volume. In fact, the form of the bird is fully realized only when the bowl is inverted; then the bird seems an almost independent sculptural entity. Very likely it is a hawk, perched on a small rod, pecking the underside of one of its wings. Although the bird is an integral part of the bowl, the representation is nevertheless remarkably naturalistic. It may have been rendered in the same workshop as the cockerel in the collection (no. 60). Certainly they are the products of the same tradition, which excelled in creating forms that are the results of realistic observation as well as flights of fancy.

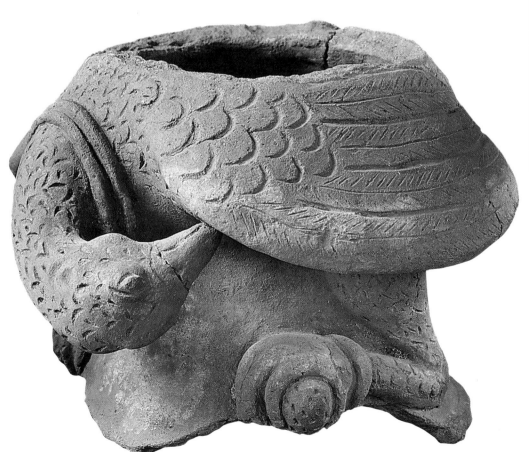

59  *Makara*
Indonesia, East Java;
thirteenth–fourteenth century
Brown terra-cotta; 24 1/2 in (62.2 cm)

An ancient motif in Indian art and mythology,
the *makara* was also popular in Southeast Asia,
particularly in Java. Along with the monster
head known as *kāla* (see no. 37), the *makara* is an
integral part of Javanese temple architecture.
Originally the word *makara* meant crocodile,
and the animal constitutes the basic component
of the composite, highly imaginative *makara*
forms created by Indian and Southeast Asian
artists. It has also remained a highly charged,
multivalent, and auspicious symbol, primarily of
fertility and plenitude.
       Although the exact function of
this terra-cotta example is not known, it is one of
the most impressive representations of the
subject in Javanese art. Its hollow shape may
indicate that it was used as a waterspout. The
attachment of a handle, however, is curious for
the vessel is much too heavy and awkward to be
portable. Whatever its purpose, it has been
designed and modeled with consummate finesse
and decorative flair.

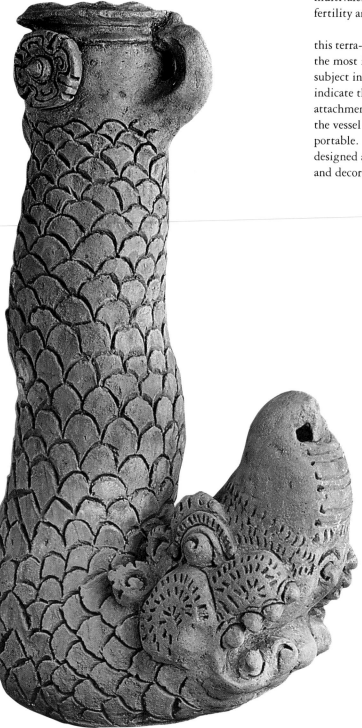

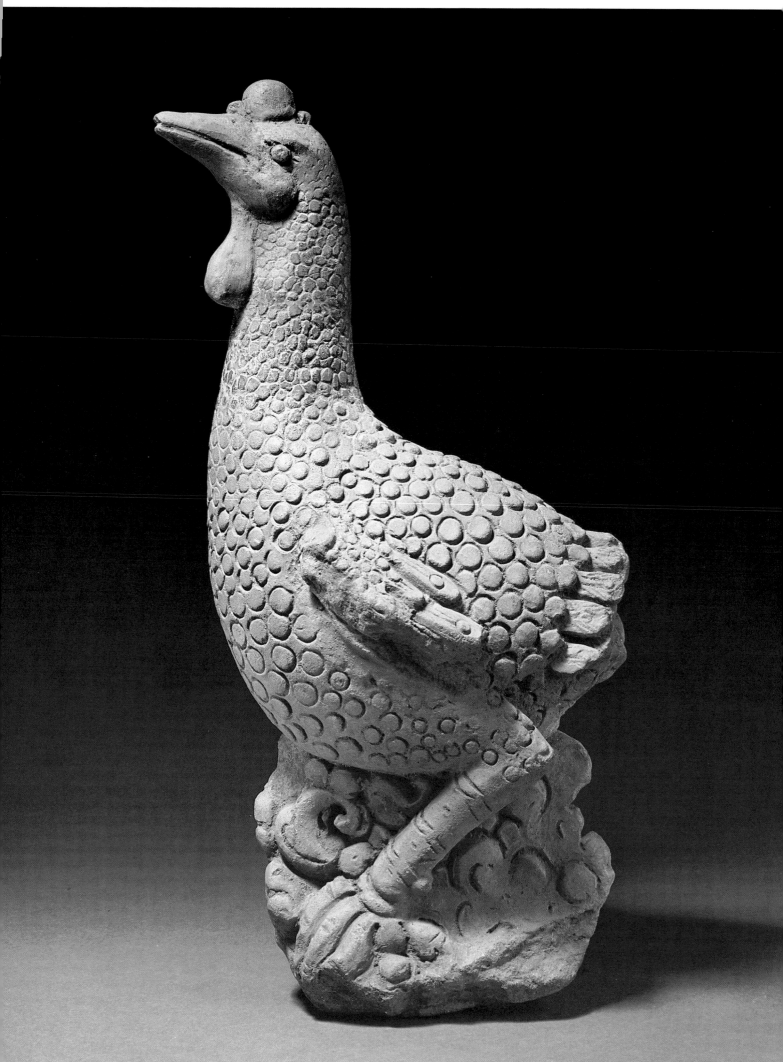

60  *Cockerel*
Indonesia, East Java;
fourteenth century or earlier
Light brown terra-cotta; 19 1/4 in (48.9 cm)
Gift of Marilyn Walter Grounds; M.84.220.7

This is a fine example of a cockerel or rooster, depicted with astonishingly realistic detail. The sculpture is conceived fully in the round and clearly demonstrates the artist's keen sense of observation and ability to render form with perceptive naturalism. Every limb and feature of the bird has been delineated with convincing fidelity and especially noteworthy is the long, graceful neck ending in a perfectly modeled head. In addition to knowing the anatomy of the bird, the sculptor was also well informed about the rooster's behavioral pattern. How lifelike is the bird's slightly cocky expression as it stretches out its neck to scout the scene.

Very likely the sculpture was intended for a building, perhaps as a roof finial. Both for its size and animated representation, this is not only one of the most impressive terra-cotta sculptures in the collection but remains unique among all published Javanese terra-cottas of the Majapahit period. (For another imposing example see Muller 1978, p. 26, pl. 37, and pp. 36–37, for a discussion of the use of cockerels and roosters in Majapahit architecture.) It has been suggested that the cockerel may have been an allusion to the name of a King Hayam, which means "spotted cock or cockerel" (Nieuwenhuis 1986, p. 75).

61    *Monster in Foliage*

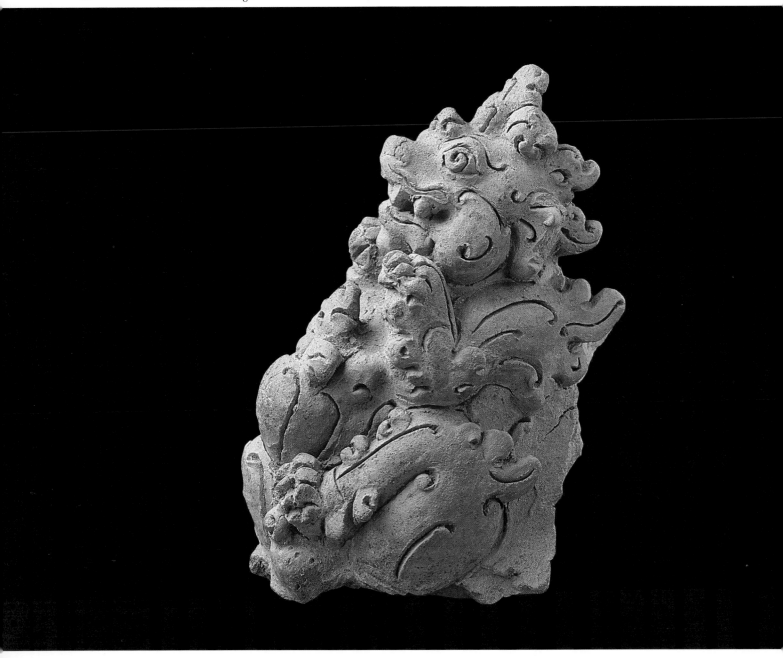

61 *Monster in Foliage*
Indonesia, East Java; fourteenth century
Buff terra-cotta; 11 1/2 in (29.2 cm)

The exact purpose of this interesting object is
not known, but it may have served as a finial or
some other architectural element. Visually
striking, it reflects the artist's remarkable skill
in conjuring fabulous forms and shaping them

with conviction. The whimsical rendering of the
figure of a rearing monster has been deftly
integrated into stylized foliage to create a lively,
but intriguing composition. The assimilation is
subtle, and the vegetation does not obscure the
creature's appearance or expressiveness. Despite
its menacing countenance, the monster seems to
sit on its haunches with raised paws like a
performing dog. (See Muller 1978, pp. 68–91,
for discussion of architectural ornamentation.)

62 *Piggy Bank*
Indonesia, East Java; fourteenth century
Terra-cotta with brown slip;
4 3/4 x 6 3/4 in (12.1 x 17.1 cm)

Remarkably well-preserved, this money box in
the form of a pig is a fine example of a type of
utilitarian sculpture that appears to have been
extremely popular during the Majapahit period.
All known examples have a slit on their backs,
evidently to insert coins (see Muller 1978, pp.
27–31, for other examples and a discussion of

the subject). Considering that individuals would
have broken into them to retrieve their contents,
it is surprising that so many specimens have
survived, a few almost unscathed.

Javanese artists obviously were
very fond of the animal, for such piggy banks
have been consistently rendered with empathy
and charm. Not only are the animals modeled
with perceptive naturalism, but often they are
imbued with personalities, as if the artists were
giving form to individual pigs that they had per-
sonally observed. In this case the artist may have
attempted to depict a pregnant pig or a boar.

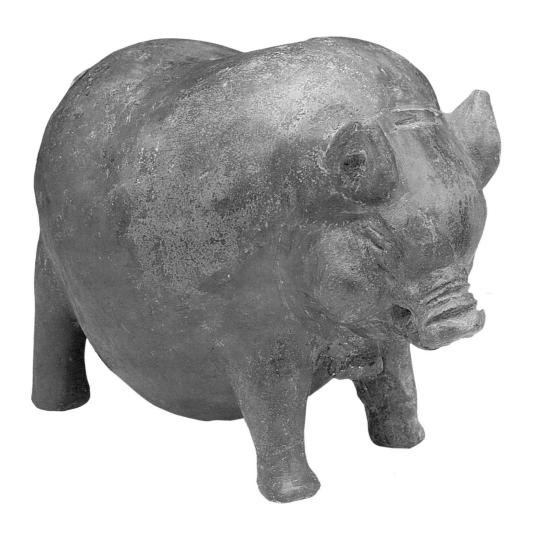

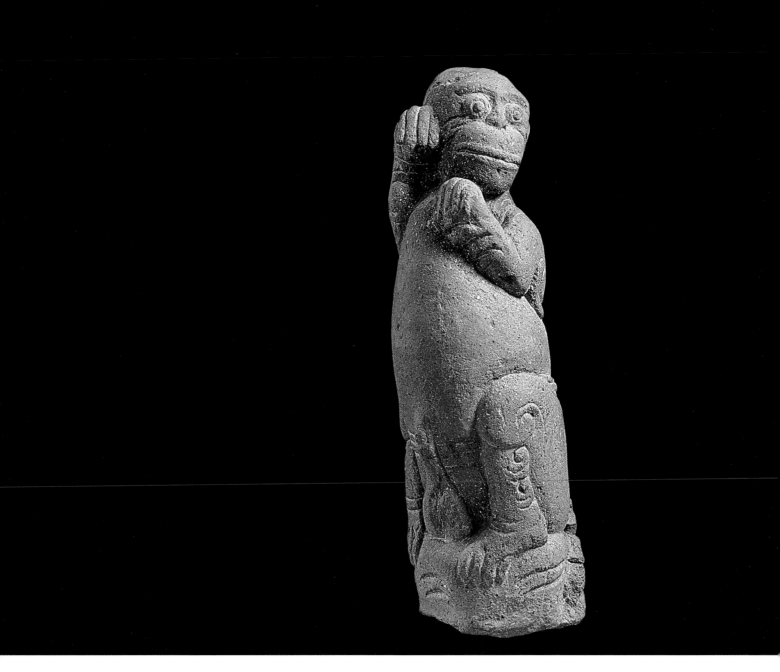

63   *Monkey*
Indonesia, East Java; fourteenth century
Light brown terra-cotta; 6 1/8 in (15.5 cm)

Not only is this one of the most intriguing objects in the collection, but it is also one of the most droll and perceptive animal representations. It is, moreover, a remarkable configuration of simple and abstract shapes, combined with uncannily realistic expressiveness.

The animal poses theatrically, displaying an erect phallus while scratching his ear. One cannot help but appreciate the sculptor's sense of humor and understanding of simian behavior.

Whether or not the object is a creation of pure whimsy or of cultic significance is difficult to determine. That it was meant as an erotic object is apparent not only by the monkey's ithyphallicism but also by the object's phallic shape. Whatever its function, it remains a singular object of charm and humor.

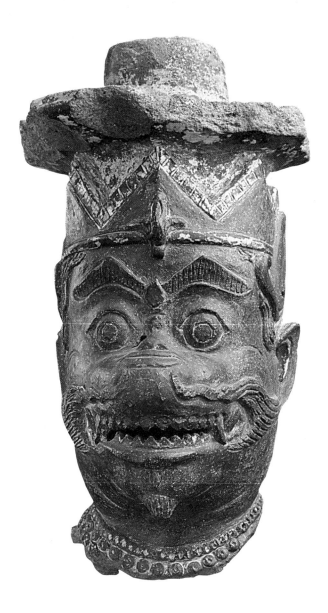

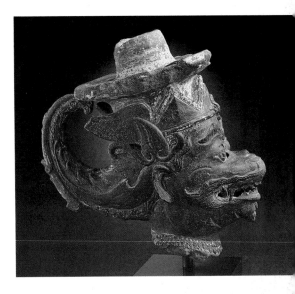

64   *Head of Hanuman*
Indonesia, East Java; fourteenth century
Terra-cotta with red slip; 9 3/4 in (24.7 cm)

This simian head probably belongs to an image of the monkey god Hanuman, the devoted friend of Rama, the divine hero of the *Ramayana*. The tiara and necklace indicate that this is a head of Hanuman rather than of an ordinary monkey. In pre-Islamic Indonesia the *Ramayana* was the most popular source of artistic expression in Java, and it still provides the principal themes for dances and puppet shows. While in India Hanuman is the focus of a cult, it is not known whether in Java such images were worshiped in shrines or were part of a temple's sculptural program. The Walter-Grounds collection includes another stucco head of Hanuman; a third example, in the Rijksmuseum voor Volkenkunde, Leiden, has been misidentified as a naga head (Thomsen 1980, p. 113, no. 120).

The grinning mouth and stylish moustache make this face particularly expressive. In addition to the tiara, Hanuman also wears a broad-brimmed hat. The elegantly decorative appendage at the back of the head may represent his hair or some kind of hair ornament.

65  *Architectural Finial*
Thailand, Sawankhalok (?); fourteenth century
Glazed terra-cotta; 21 1/4 in (54.0 cm)

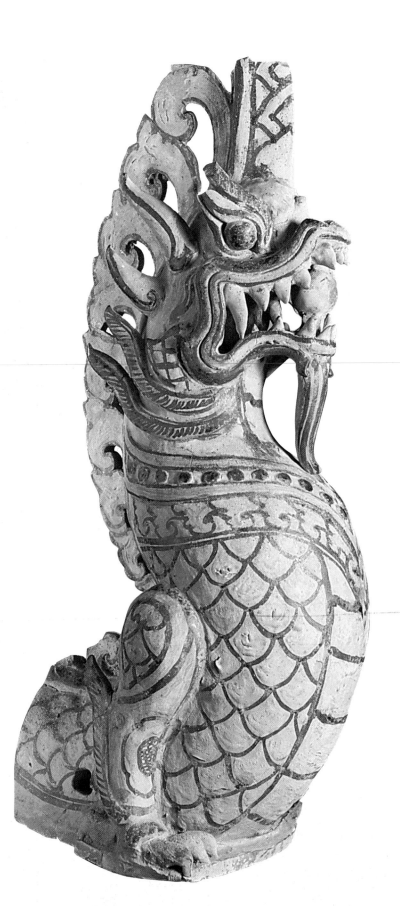

Among the most popular forms of guardian figures used by Thai architects to protect their religious edifices are yakshas (see no. 81), nagas, lions, and mythical creatures of Indian origin known as *makaras*. While this familiar figure in Thai ceramic ware is generally identified as a lion, its sinuous and fantastic form resembles that of other creatures, namely, the Chinese dragon and Indian *makara*. Such figures either adorned balustrades or were placed with striking effect at the corners of buildings where the cornices joined the gables.

    This particular example in glazed terra-cotta is probably from Sawankhalok, in western Thailand, where during the fourteenth and fifteenth centuries local artists created wonderfully whimsical creatures by combining Chinese, Khmer, and Thai decorative elements (Stratton and McNair Scott 1981, pp. 135–36). As is usual in such works, the limbs, facial features, scales of the body, and ornaments are all highlighted in brown over a gray or beige slip. Not only do the brown highlights enliven the surface, but they also articulate the modeling. Indeed, these stylized ceramic lions are among the most original elements of Thai architectural embellishments.

*66a–b   Two Tiles with Animals*
Sri Lanka; fourteenth century (?)
Reddish brown terra-cotta with lime plaster;
*a,* 10 3/4 in (27.3 cm); *b,* 5 3/8 in (13.6 cm)

The exact provenance of these two tiles is not
known, but they originally decorated the eaves of
temples or palaces. Stylistically both tiles are
related to another from Padeniya (Godakumbura

1965, p. 16, no. 15). There too an animal with a
neck collar is rather sketchily rendered, making
it difficult to identify precisely. One animal (*a*)
may represent a dog and the other a stylized lion.
In any event, as in the others, the animals are all
shown looking up and howling, as if at the
moon. This may have been deliberate, to scare
evil spirits away from the building.

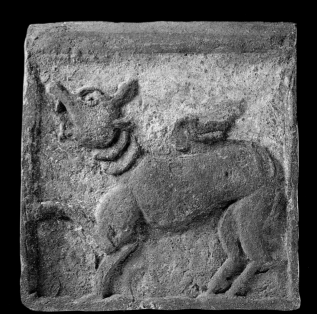

67a

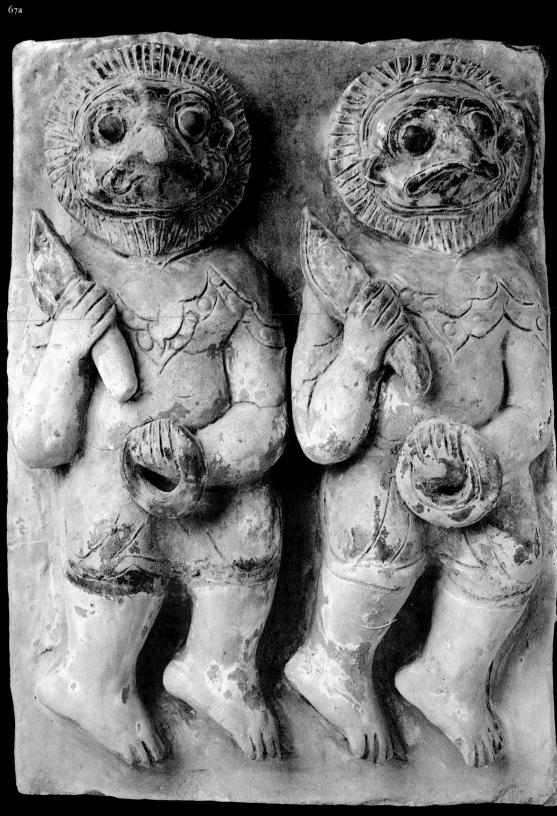

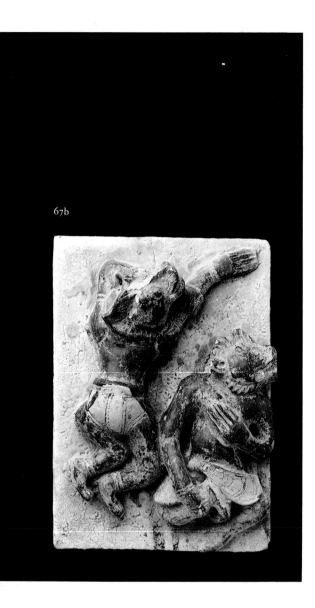

67b

*67a–b  Two Tiles with Demons*
Burma; fifteenth century
Glazed terra-cotta;
*a,* 16 1/2 in (41.9 cm); *b,* 18 in (45.7 cm)

These two glazed tiles, embellished with strikingly whimsical demon representations, are among the most impressive examples of such objects from Burma. The style of these tiles is similar to those adorning niches of buildings that stood beside Shwegugyi Pagoda, constructed near Pegu by King Dhammacheti (r. 1472–92) (Zwalf 1985, pp. 162, 164, no. 226). The structures were meant to commemorate the first seven weeks of the Buddha's enlightenment. Appropriately some tiles depict animal and bird-headed monsters, who, led by their leader Mara, god of earthly desire, attacked the Buddha while he meditated under the bodhi tree at Bodhgaya.

Holding swords and rings, the owl-headed monsters stand like soldiers in line. Their feather halos resemble Elizabethan ruffs. Much of the glaze has worn away, but traces remain to show that the heads and garments were covered in rich brown and black. The cloud collars, or capes, around their necks were probably painted light blue, whereas the pupils, eyebrows, and noses were articulated in gray-black. (For another tile with owl-headed monsters said to be from Pegu, northeast of Rangoon, see *Arts of Asia* [November–December 1985]: 55).

The two animal-headed monsters on the other tile are much more animated and leap about with agile, contorted bodies. Except for their small loincloth patches, the figures are covered in dazzling turquoise glaze. While glazed tiles have been commonly used in Burma to decorate buildings and temples, these fifteenth-century examples are unusual for their size and brilliant glaze. Their lively and imaginative bold relief also make these tiles remarkably attractive.

68    *Noble Lady*
India, Bihar, Patna (?); second century B.C.
Red terra-cotta; 6 5/16 in (16.0 cm)

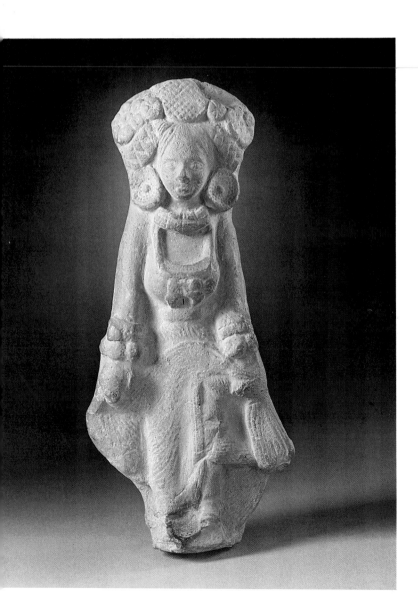

In contrast to the somewhat flat delineation of the body, the figure's breasts are rather pendulous. The elegant lady wears an elaborate headdress and stylish garments, parts of which she holds across her thighs. In the modeling, dress, and ornamentation the figure is strongly akin to the celebrated terra-cotta females found in and near Patna. The capital of the Maurya Empire, known then as Pataliputra, Patna has yielded some of the most sophisticated terra-cotta figures in the history of Indian art (for a stylistic analogue see Shere 1961, Patna, no. 12).

Such figures have variously been identified as apsaras or yakshis but without much evidence. If they represent divine figures and were used as cult objects, they certainly lack the hieratic quality of third-century B.C. Mathura figures (see no. 1). Nevertheless, they were very likely modeled after the elegant ladies of the Maurya capital.

### 69     *Amorous Couple*
India, Uttar Pradesh, Kausambi;
second century B.C.
Red terra-cotta; 4 in (10.2 cm)

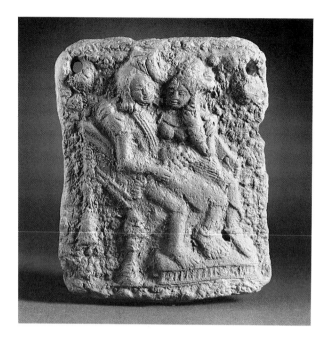

An amorous couple in dalliance is seated on a couch. They both are elegantly attired and richly bejeweled. The male is a prince or merchant, while the woman may be a courtesan. It has also been suggested that they may represent a newly wed couple. Several other identical examples from the same mold are known, and apparently the subject was popular during the Śuṅga period (Lee 1964, no. 25; Kala 1950, pl. XV, for a fragmentary piece). The two holes at the top indicate that the piece may have been hung as a wall decoration or used as a charm. In addition to depicting social life among the sophisticated citizens of the period, the plaque also describes contemporary furniture design. Both the chair and footrest are quite distinctly delineated.

In Sanskrit literature these couples, whether in dalliance or not, are known as *mithuna* or *dampati*. Regarded as symbols of auspiciousness and fecundity, they are a constant presence in later Indian temples, especially on either side of a doorway. Whether these terra-cotta plaques were used in fertility cults or simply as decorative objects is not known.

### 70     *Amorous Couple*
India, West Bengal, Chandraketugarh;
first century B.C.
Red terra-cotta; 3 3/8 in (8.6 cm)

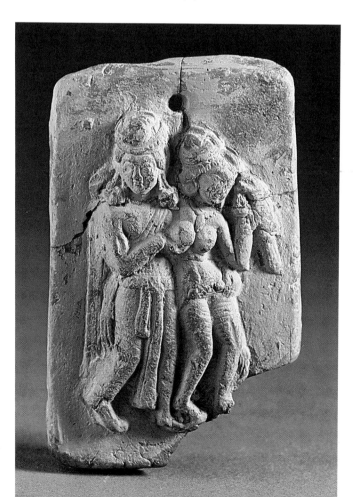

While the male begins his amorous advances by encircling the lady's waist and caressing her breast, the female quickly begins feeding her pet parrot to distract the bird so that it will not indiscreetly repeat their conversation later. The motif is well known in Sanskrit literature. A fine verse included in the seventh-century anthology of court poetry known as the *Amaruśataka* (Amaru collection) narrates the story described in the much older plaque:

The pet parrot, having heard the words
of last night's love between the bride and groom,
begins to tell them shrilly on the morrow
    before their elders.
The bride, quite overcome with shame,
offers before his beak a ruby,
like a pomegranate seed, drawn from her
    necklace,
to stop his chatter (Ingalls 1965, p. 213).

71   *Male Head*
India, Uttar Pradesh; c. 300
Buff terra-cotta; 9 1/2 in (24.1 cm)

Almost life size, this well-preserved head may
have once been attached to a statue of an
important lay person. Although the features
(thick lower lip, large, staring eyes, and
elongated earlobes) are idealized, the head may
be a realistic representation of a donor. The
elegantly rolled turban also precludes an
identification with a god. Terra-cotta portrayals
of mortals appear to have been quite common
during the Kushan and Gupta periods. Several
similar heads of varying sizes recovered from
Kausambi have been attributed to the Kushan
period (Kala 1980, pls. 226, 228–30, 236–38,
243, 250–52, 254–56). Some appear to be
distinct portraits, and several wear rolled
turbans (ibid., pls. 250–52, 255–56) very
similar to this example. While most of these
heads are from Kausambi, some are from
Rajghat, near Varanasi.

### 72    *Plaque with Horse and Rider*
India, Uttar Pradesh; fifth century
Reddish brown terra-cotta; 8 1/4 in (20.9 cm)

This partly preserved plaque depicting the forepart of a horse with rider probably decorated a Gupta-period temple. Many such temple plaques have been recovered in recent years both from Uttar Pradesh and Haryana, and some clearly depict themes and stories from the *Ramayana* (see no. 20).

Represented in high relief with rounded volume, the galloping horse and rider emerge from the background. As in other Gupta-period reliefs, the sculptor succeeded in enhancing the three dimensionality of the composition by extending parts of the characters' limbs beyond the raised frame. His boots, clothes, and conical cap identify the youthful warrior as a Scythian or Parthian. A bow is slung across his chest, and a quiver of arrows is attached to his thigh.

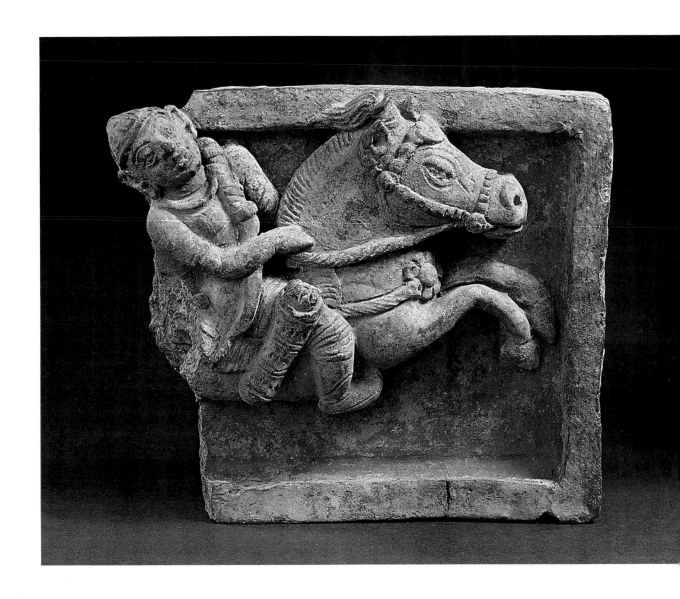

73   *Male Head*
India, Kashmir, Jammu District, Akhnur;
early sixth century
Reddish brown terra-cotta; 6 1/2 in (16.5 cm)
Gift of Marilyn Walter Grounds; M.85.284.6

An important Buddhist site in the district of
Jammu in Kashmir, Akhnur has yielded a
large number of terra-cotta heads that are
fascinating for their variety and technical
proficiency. When first discovered, the site was
dated to the eighth century (Fabri 1955), but
recent investigations corroborate the sixth-
century date proposed by Moti Chandra (1973b;
see also Paul 1986). The discovery of Gupta
coins and inscriptions at the site indicates that a
sizable Buddhist monastic establishment was
built there during the Gupta period. More
interesting is the fact that many heads recovered
from the site appear to represent lay persons and
are remarkable both for their sensitive modeling
and ethnic diversity.

This particular head is similar
to several others and is distinguished by its
hairstyle and elegantly twirled moustache.
Characteristic of the Akhnur heads, the face is
full and fleshy, the eyes are large and wide open,
and details of the hair are very realistically
rendered. Typical also is the manner in which the
eyebrows are joined above the bridge of the nose.
Very likely the head represents an idealized
donor portrait, the unusual hairstyle indicating
that the individual is a Central Asian.

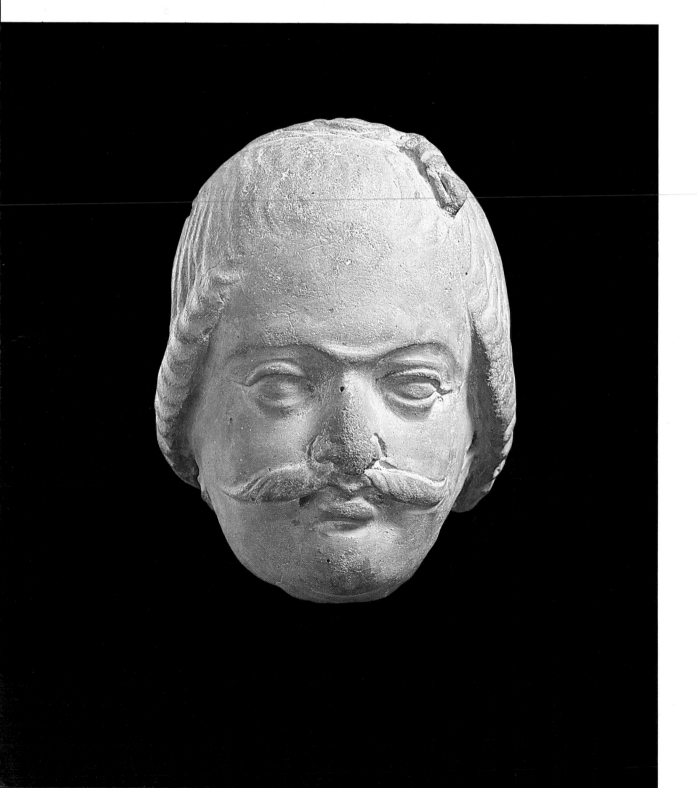

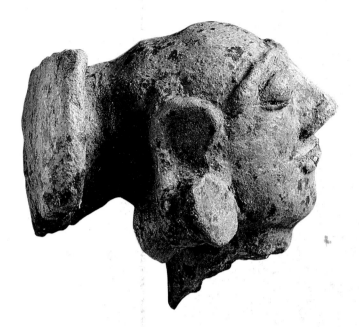
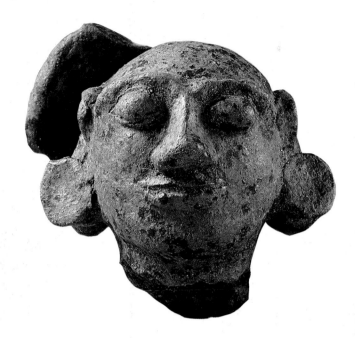

**74    Male Head**
Sri Lanka; c. sixth century (?)
Red terra-cotta with traces of black pigment;
3 3/4 in (9.5 cm)

In contrast to most other anthropomorphic
figures from Sri Lanka included here, this well-
modeled head represents a more sophisticated
figure. The face is dominated by a strong, flaring
nose and large, bulging eyes. The large ears are
adorned with drum-shaped ornaments. The
extension at the back, ending in a broken disk or
ring, suggests that the hair was pulled back
(south Indian brahmins even today wear their

hair in this way). Thus the head may represent a
brahmin or member of the upper classes or a
deity, if the disk represents a nimbus.

The head is comparable with
several terra-cotta sculptures discovered at
various sites and now in the Anuradhapura
Museum (Godakumbura, n.d., pls. 22–27). All
are distinguished from the more primitive votive
figures by their urbanity and individuality and
are stylistically more closely related to the stone
sculptures of Anuradhapura (Lohuizen-de Leeuw
1981, figs. 35–43).

**75    Male Head**
Sri Lanka; first millennium A.D.
Red terra-cotta; 4 1/2 in (11.4 cm)

Neither the exact date nor function of this
remarkably expressive head is known. The
masklike face and stylishly elegant coiffure make
this a strangely attractive sculpture. The face is
both sensitively and forcefully modeled, while
the sweep of hair adds a lively, dramatic touch.
Terra-cotta heads discovered in Sri Lanka reveal a
remarkable variety of abstract, primitive, and
even bizarre features (Godakumbura, n.d.), but
few are as impressive either for their size or sense
of mystery.

76    *Male Guardian*
Indonesia, Java; c. 1100
Buff terra-cotta; 21 1/2 in (54.6 cm)

Genuflecting on a lotus base, the demonic
guardian raises a club with his right hand.
Richly adorned with jewelry, he is clad in a
sarong tied rather high on his torso. His jowly
face is distinguished by a grinning mouth and
bold, wide-open eyes. The navel and nipples are
prominently incised.

Most surviving guardian
figures are made of stone, making this terra-
cotta example of unusual interest. Stylistically
the figure is notably different from those that
have survived from either Central or East Java.
Like the stone examples, this terra-cotta
guardian figure must once have protected a brick
temple. Usually in Java stone guardians kneel on
plain or skull-adorned pedestals. Here, however,
the base is a lotus, as in another unusual
guardian sculpture in a Buddhist temple in
Pandang Lawas, Sumatra (Bernet Kempers
1959, pl. 227). The proportions of that figure
are quite different from the heavier, squat stone
guardian figures. A close stylistic parallel is
offered by a large terra-cotta image of Siva from
Magelang in Central Java (Thomsen 1980, pp.
97–99, no. 93). It is possible that both these
sculptures belonged to the same temple.

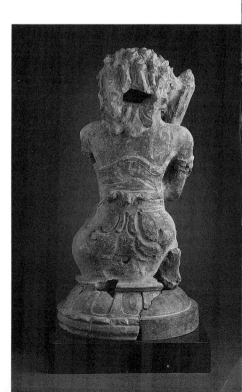